Colonial
MARBLEHEAD

Colonial
MARBLEHEAD

FROM ROGUES TO REVOLUTIONARIES

LAUREN FOGLE

THE
History
PRESS

Published by The History Press
Charleston, SC 29403
www.historypress.net

Copyright © 2008 by Lauren Fogle
All rights reserved

Cover image, top: Ships in port. Original drawing by Ashley Bowen, 1738. *Courtesy of the
Marblehead Museum & Historical Society.*
*Cover image, bottom: Tucker's Wharf, Marblehead. Courtesy Marblehead Historical Commission, Abbot
Hall, Marblehead, MA,* http://www.marblehead.com/MHCarchive/index.htm.

First published 2008

Manufactured in the United States

ISBN 978.1.59629.411.0

Library of Congress Cataloging-in-Publication Data

Fogle, Lauren.
Colonial Marblehead : from rogues to revolutionaries / Lauren Fogle.
p. cm.
Includes bibliographical references and index.
ISBN 978-1-59629-411-0
1. Marblehead (Mass.)--History--17th century. 2. Marblehead (Mass.)--History--18th
century. 3. Marblehead (Mass.)--Biography. 4. Marblehead (Mass.)--Social conditions.
I. Title.
F74.M3F64 2008
974.4'5--dc22
2008014321

For Pippa

CONTENTS

FOREWORD

Marbleheaders tend to be passionate about this town and its history. People who live here are usually fiercely, even pugnaciously, independent, but also share an abiding interest in historical facts and folklore. This respect for tradition, along with an insistence on individuality, defines an attitude that seems to have always existed here.

Dr. Lauren Fogle, raised herself in Marblehead, has combined her affection for the town with a high level of scholarship to present a stellar addition to the area of colonial history. This book retells some of the familiar stories while adding new insight through the use of primary documents.

Ever since I can remember, Marblehead has held a special place in my heart. I have heard the stories, read the history and spent the last fourteen years actively researching, caring for and sharing its past. I am honored to be a small part of this publication and I look forward to others gaining knowledge through Lauren's efforts.

Karen Mac Innis
Curator of Collections
Marblehead Museum & Historical Society

ABBREVIATIONS

EIHC: *Essex Institute Historical Collections*
TEG: *Essex Gazette*
MTR: Marblehead Town Records

Note: All quotes in this book have been left in their original form; misspellings have not been corrected and capitalization has been left as written.

ACKNOWLEDGEMENTS

M y sincere thanks go to my editors Jonathan Simcosky and Hilary McCullough, and everyone at The History Press; to Karen Mac Innis and Pam Peterson of the Marblehead Historical Society; to Wayne Butler and Chris Johnston of the Marblehead Historical Commission; to those in the town clerk's office; and to Tony Sasso, the selectmen's administrator. I also want to thank Harold Bantly, archivist of the Old North Church; George Schwartz and Christine Michelini of the Peabody Essex Museum; Barbara Kampas of the Philips Library; Polly Tritschler; and John Fogle. I would not have been able to complete this work without the unconditional support of my husband, Andrew, and the loving attention that Jean and Jenna Fogle and Meghan Carr gave to my daughter, Pippa, while I was researching and writing this book.

At this date, the town consisted mainly of forest and rock. The area between the Forest River (near the Salem border) and the ocean (south of today's Ocean Avenue) was known as the Plains because it was fairly flat and most of the town's larger farms were founded in this area.[7] The area in the vicinity of the current Tedesco Street was mostly swamp, which was divided into eight parts and allocated over time to various inhabitants. At the far end of the swamp was John Legg's farm (near Leggs Hill Road).[8] The large harbor of the town was called the Great Harbor or the Great Bay, but it was Little Harbor (Gas House/Orne Street beach) that served as the main harbor in the seventeenth century, since it was closer to the main settlement.[9] The part of town nearest Little Harbor was known as "the Main." The land that ran from Peach's Point to Naugus Head was called John Peach's Neck, and everything from Naugus Head to the Salem border was known as "the Forest Side."[10] At Naugus Head (or "Nogg's Head," as it was first called) was the original ferry to Salem, which was started at least by 1637, but possibly before.[11] The cove currently called the Landing was officially stipulated as a landing place for use of the public in 1662, though it had been used as one for years prior.[12] Marblehead Neck was called the "Great Neck" and was completely covered by three hundred acres of trees. The Neck also had two ponds, one on the southeast shore and another at the southwest end. On the northwest shore there was a spring that the fisherman used for fresh water. Much of the timber used by both Marblehead and Salem was taken from the Neck, to the point where deforestation was becoming a problem and the Marbleheaders regulated against the practice in 1678.[13] A road to the Neck was first attempted in 1669–70, beginning at the current Smith Street, and the town's cattle started grazing there.[14]

Town Growth

The first real industry in Marblehead was the fishery begun by Isaac Allerton in 1631. Allerton was one of the passengers on the *Mayflower* and had been a successful but controversial merchant and one of the leaders of the early Puritans in Plymouth. However, due to suspect business practices, he was ordered to leave the colony in 1635. His son-in-law, Moses Maverick, inherited his fishery, which originally had eight boats but lost one at sea in 1633.[15] Three years later, the third ship ever built in the colony was built in Marblehead. It was called *Desire* and was initially a fishing boat, but later sailed to the West Indies and brought back salt, tobacco, cotton and the colony's first black slaves.[16] In 1635, a Dutch ship from St. Kitts (then known as Christopher Island) moored at Marblehead carrying 140 tons of salt and

10,000 pounds of tobacco.[17] John Deveraux, who owned a large tract of land along the ocean, just south of the way to the Neck, had a small fishing export business that supplied fish to Boston merchants. Deveraux hired the men to catch the fish and then dried and packaged it and shipped it to Boston. Other Marbleheaders like John Peach and William Nick ran similar, small-scale operations.[18] The cost of starting such an operation was still out of the reach of many men. A four-man team consisting of three fishermen and one shoreman (to organize and ship off the catch) might cost between £100 and £150 a year—which amounted to one to two years' income for each of the employees. These costs put many early fish merchants heavily in debt, often to each other.[19]

As the population slowly grew, land was granted to individuals for houses, gardens and pastures for animals. John Peach was granted land at what is now called Peach's Point (land that he had almost certainly been occupying prior to the grant). Nicholas Marriott received land near Little Harbor, on Merritt Street (the street's name clearly stemming from his own). One of the first merchants, John Throckmorton, gained a landing place for boats near Peach's Point.[20] Certain areas were reserved for firewood and any public land was known as "the commons." Sometimes individuals attempted to sell land that actually belonged to the commons, as Thomas Davis did when he sold a plot to Richard Norman. This same plot was simultaneously sold by Henry Pease to Richard Downing. Meanwhile, George Corwin sold five shares of the common land, even though he only legally owned three.[21] The courts at Salem attempted to straighten out these property matters, but confusion was rife in the early years, and disputes between townspeople were frequent. Eventually, the town "common" became the land on which Abbot Hall now stands.

For the most part, the inhabitants were falling into three distinct groups. At Little Harbor were the fishermen and boat builders, many working for Matthew Craddock of the Massachusetts Bay Company. At the upper part of town, along Salem Harbor and toward the current Swampscott border, were lands granted by Salem to some of its own people, like John Humphrey and Reverend Hugh Peter. The first proposed site for Harvard College was within the limits of John Humphrey's land.[22] However, the Salem authorities soon learned that granting unlimited land to the fishermen might drive them into farming and away from the sea. Since starting a fishery was deemed to be in everyone's interest, a house plot and two acres were all the fishermen would receive in the future.[23] If an individual built on land that had not been granted to him he was fined, as John Gatchell was in 1637.[24] By 1648, a group of early settlers had bought a section of John Humphrey's land and broken it down into ten-acre lots. Those who did not buy into the farm but were also early settlers were called "commoners" and occupied much

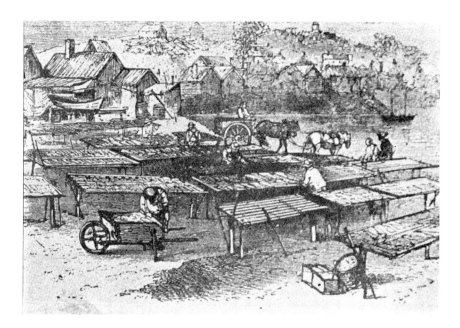

The fish flakes were used for drying fish. *Courtesy Marblehead Historical Commission, Abbot Hall, Marblehead, MA, http://www.marblehead.com/MHCarchive/index.htm.*

necessary trait, since throughout the town's history, until the final collapse of the fisheries in the mid-nineteenth century, the men were often away on ships, leaving the women to ensure the survival of their families.[48]

A second challenge the early Marbleheaders faced was their own heterogeneous backgrounds. Unlike many other early towns in the Massachusetts Bay Colony, the settlers of Marblehead were not all English. A good number of them came from the Channel Island of Jersey, which in the seventeenth century was "geographically, linguistically, and culturally closer to France" than England.[49] There was a common prejudice against those from Jersey, as exhibited by a Marblehead constable who brought a Jersey man, John Brock, to court for refusing to join the town watch. Witnesses to the attempted arrest, which took place at a tavern, testified that the constable was overly harsh and the justices of the court agreed. Though they reprimanded both sides, they claimed that "ethnic motivations" were obvious.[50] Others immigrants came from the west country of England (Cornwall and Devon) and Newfoundland, which itself housed a mix of Welsh, Irish, English and Jersey immigrants. This diversity caused strife as the different groups built factions and often fought with each other or refused to conduct business outside their own circles. Even a century later, Marbleheaders had a distinct dialect and accent, which made them difficult

to understand for many other Massachusetts colonists.[51] As a result, many of their names were misspelled in the records and some were permanently changed that way.

The combination of a disproportionate number of single men in the town (some were married but had traveled to Marblehead without their wives and families) and the multiethnic makeup of the residents made for a relatively high crime rate. Christine Leigh Heyrman, in her book *Commerce and Culture: The Maritime Communities of Colonial Massachusetts 1690–1750*, performed an in-depth analysis of the crime rates in both Marblehead and Gloucester. Her findings indicate that Marblehead had a significantly higher instance of criminal activity than Gloucester in the later seventeenth century.[52] For example, in Marblehead in the 1670s, six townspeople were prosecuted for assault, ten for slander, nine for challenging the authorities, thirteen for selling liquor without a permit, five for taking the Lord's name in vain and three each for rape, lewd behavior, stealing and violations of the Sabbath (almost anything other than attending church on Sunday was considered a violation, including rolling a cask and gathering peas).[53]

Marbleheaders were a rough lot and they had that reputation throughout the colony. The prevalence of taverns in the town may have had much to do with this. The very first tavern/inn was probably licensed to Arthur Sanden in 1641, on Front Street. Moses Maverick, the new owner of the first fishery, was licensed to sell a ton of wine around that date, though it is not certain that he sold all of it in Marblehead.[54] The Three Codds Tavern opened on Front Street in 1680 and Samuel Reed's (Read's) tavern was on the corner of Washington and State Streets from 1678 to 1718. There were at least two other taverns licensed in the late seventeenth century, one to Christopher Lattimore (near the Landing) and one to Lieutenant Richard Norman.[55]

The fine for public drunkenness on a Sunday was steep in 1633, when James White was charged thirty shillings for the offense, but fines alone did not deter the townspeople from indulging.[56] Even at town meetings, the residents drank alcohol and often created disturbances. The erection of a "lentoo" (a lean-to) onto the meetinghouse was an occasion for feasting on fish and passing around the rum.[57] By 1678, the selectmen appealed to the courts of the colony to allow them to refuse any new licenses to sell liquor in the town. There was "much disorder" in Marblehead, they complained, and "the sin of drunkenness" was the culprit.[58] When the constables were sent to clear out the taverns and break up fights, they were met with resistance and, more than that, a questioning attitude as to why they should attempt to keep the peace at all. As historian Daniel Vickers put it,

The rowdy conviviality of drinking in company mattered to the maritime community, partly because the smoke and crowded warmth of the tavern were a comfort to men who worked in the cold and wet, but also because this waterfront tavern culture defined a corner within New England society where Puritan teachings were mocked.[59]

To be sure, law and order were not popular with many in Marblehead. But then, why should they have been, considering the lack of trust most of the people had in their chosen leaders? The aforementioned constable, John Waldron, who was sent to close down a tavern owned by Christopher Lattimore, was reportedly drunk himself. Nearly half of the selectmen who served from the 1630s to the 1670s were at some point prosecuted for an offense, including breach of the peace.[60] If you had asked a member of Salem's Puritan leadership about Marblehead, they would have probably said that the town's wayward inhabitants were a ramshackle bunch of godless people who desperately needed a church. It is true that Marblehead had no official church until 1684, over fifty years after the original settlement. Any townspeople who wanted organized worship, or communion, went to Salem and several Marbleheaders were admitted as members of Salem's First Church.[61] In fairness, the Marbleheaders did attempt to bring a minister to the town in 1633, when John Avery was sent for from Newbury, but his ship sank off Cape Ann and he and his family were lost.[62] The first meetinghouse was built in 1638 on a hill near Little Harbor, now known as Old Burial Hill, but the man who actually preached there, William Walton, was not an ordained minister and called the Marbleheaders a "lawless, God-forsaken people among whom laboring seemed useless."[63] The admiration went both ways. Many townspeople had little time for the church and certainly there was nothing like the respect for the Puritans in Marblehead as there was in other New England towns in this period. Even after the First Church was established in 1684, with a properly ordained and Harvard educated man at the helm, membership was low and years passed without a new person joining.[64]

Heyrman has argued that this lack of religious unity, combined with the dislike of authority and the rule of law, made Marblehead a town but not a community. In many ways she is right, especially when Marblehead is compared to other towns of a similar size, like Gloucester, where the levels of disruption and discord were much lower. But the Marbleheaders, unruly as they were, did make an effort to take care of their own. Widows and the poor, for instance, were often supported with public funds. An almshouse was built in the eighteenth century to house the destitute. Even during the Salem witch trials of 1692, only one Marbleheader, Wilmot Redd, was charged and it was the Salem girls, not her fellow townsfolk, who accused her. Although

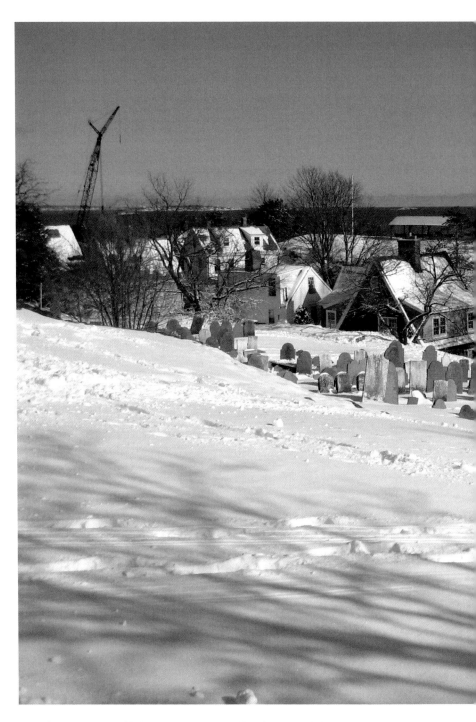

View from Old Burial Hill toward the harbor. *Photo by Lauren Fogle.*

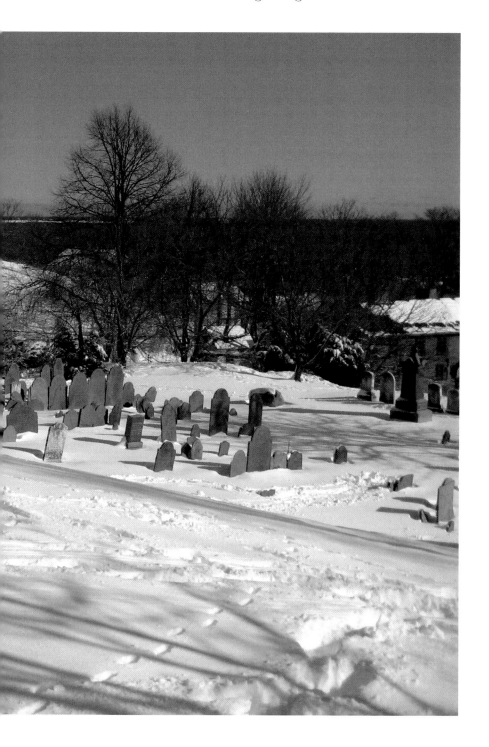

The house once occupied by Wilmot Redd, the only Marbleheader hanged as a witch, in 1692. *Photo by Lauren Fogle.*

a number of Marbleheaders were summoned to Salem to testify against "Mammy" Redd, and some of them did, there was no further spread of the hysteria and no attempt to curry favor with the Puritan overlords by offering tales of the "witches" of Marblehead.[65]

There were at least a few God-fearing people in the town, otherwise such an account could not have been written in 1699 by a traveling Quaker from England, Thomas Story.

> *We had a meeting* [prayer service] *at Marblehead; where there is not a friend* [another Quaker]*: The Meeting was pretty large, and the People sober. The Creation of Man, his first State of Innocence, his Fall, present State of Nature, and Restoration by CHRIST the Second Adam, were Subjects of the Testimony: and the diving Truth the good Dominion over the People; who, after the Meeting, were loving, and behaved rather with awful Respect than light chearfulness, of Familiarity.*[66]

Anti-Puritan solidarity aside, Marblehead's dire economic situation was at the root of many of its problems. The majority of the fishermen in the town worked on boats they did not own, for men who were often not even from Marblehead. Much of the investment in the Marblehead fishery was initially from Boston and as far away as England. Boston merchants reaped the profits, while Marbleheaders fell further into debt.[67] This was by design. The ship owners wanted a dependent pool of workers to keep the fishing business going, but also to stay firmly in their places. The fish caught by Marbleheaders was neither of the highest quality nor bound for the biggest ports of Europe and the West Indies (as it would be in the following century), but was destined mainly for the colonial market.[68] These local markets were often oversaturated, which brought down the price of fish and directly impacted the fishermen of Marblehead and their families. Worse than falling fish prices was the constant threat of weather-related disasters and the loss of ships, men and cargo. The weather in the year 1667 was so bad for the fishermen that the town's colony tax was waived for one year.[69] Wars had a similar effect: ships were raided, men were pressed into service and even the harbor was not safe from a possible attack. The Anglo-Dutch war of the 1660s, King Philip's War and, most importantly, the Anglo-French war at the end of the seventeenth century all contributed to a long-lasting downturn in the economies of fishing towns.[70]

As the dawn of the eighteenth century approached, Marblehead was a poor town, completely dependent on the fisheries, which were affected by everything from weather to war. Its multiethnic inhabitants were often at odds with each other, and with the Puritan ideal of much of the rest of

the colony. A fledgling town government, well intentioned as it might have been, was unable to affect the economics of the fisheries, nor to rally its townspeople into forming a more cohesive, united community. For those living in Marblehead at this time, the future must have seemed uncertain at best, bleak at worst.

Daily Life: Living with Animals

In seventeenth and eighteenth-century Marblehead, the townspeople lived in extremely close quarters with their animals. Horses might be in stables, or simply tied up outside a house, but there was undoubtedly little separation between the owners and their means of transportation. The streets being narrow and irregular, the galloping of horses through the town frequently resulted in accidents, often involving children. In 1675, the town issued an ordinance against the galloping of horses after too many children had been run over by them. One child was kicked to death by a horse in 1768. Less dangerous perhaps, but still a nuisance, were geese and gander, pigs, sheep and cattle, which often escaped their fenced-in pastures and roamed around the town. There were fines imposed on anyone whose fences were in disrepair or allowed their animals to wander freely. However, these animals were sometimes as hazardous in death as they were in life. By 1673, there were so many animal corpses cluttering the streets that the town leaders felt disease would surely result. Therefore, when an animal died its corpse was ordered to be disposed of (most often in the ocean) within twenty-four hours under penalty of a ten-shilling fine.

A TOWN'S FAITH

From Church to Meetinghouse

Religion had a rather undistinguished beginning in Marblehead. Unlike Salem and many of the other early New England towns, the devout faith of the Puritans did not bind the community together against the dangers of Indian raids and the hardships of harsh winters. The Marbleheaders were aloof to religious rules and norms; they put their faith in the sea and, more than they might admit, in wine. Even the fervor of the Salem witch trials failed to cause much of a stir in Marblehead. As Heyrman put it, "That Marblehead had gone to the devil was too evident to require exposure, and charges to that effect would have created little sensation in Massachusetts." However, this all began to change when a new minister came to town.

The Candidate Debate: John Barnard versus Edward Holyoke

At the First Church, the only church in Marblehead, a change was needed. Reverend Samuel Cheever, who had been struggling with the heathen townspeople for decades, was preparing to retire and a new pastor was needed to first assist, and then replace him. Cheever had not been particularly successful in Marblehead; church membership was low and there was little church/community comradeship. In 1714 his son, Ames Cheever, was in the running to replace his father, but his candidacy was soon eclipsed by two others: John Barnard and Edward Holyoke. These men were both Bostonians, both Harvard educated and both espousers of the Congregationalist orthodoxy pioneered by preachers like Cotton and Increase Mather. In fact, Barnard was a protégé of the Mathers in his younger years. In their attitudes as well as their beliefs, Barnard and Holyoke were more similar than they were different. Nevertheless, when the

Sketch of the original First Church meetinghouse. *Courtesy Marblehead Historical Commission, Abbot Hall, Marblehead, MA, http://www.marblehead.com/MHCarchive/index.htm.*

male congregation voted seventeen to eleven for Barnard, the supporters of Holyoke refused to give way. The election done, the town leaders informed Barnard of the decision in February of 1715, but Barnard had heard the rumors that a good number in the congregation were still pushing for Mr. Holyoke, so he initially declined the offer.

Eschewing the risk of oversimplification, the tension between the two camps came down to this: the backers of Barnard were mainly the established, old families of Marblehead. Some were more prosperous than others, but many were poor fishermen and tradesmen. These townspeople distrusted and were threatened by the second group, the backers of Holyoke, who were mostly newcomers to town. These newcomers were predominantly

trading vessel belonging to the town, nor for several years after I came into it; though no town had really greater advantages in its hands. The people contented themselves to be the slaves that digged the mines, and left the merchants of Boston, Salem, and Europe, to carry away all the gains; by which means the town was always in dismally poor circumstances, involved in debt to the merchants more than they were worth; nor could I find twenty families in that, upon the best examination, could stand upon their own legs; and they were generally as rude, swearing, drunken, and fighting a crew, as they were poor. Whereas, not only are the public ways vastly mended, but the manners of the people greatly cultivated; and we have many gentlemen-like and polite families, and the very fisherman generally scorn the rudeness of the former generation.[84]

Barnard went on to explain how he came to be of assistance. He befriended the captains of some of the English trading ships in order to learn "the mystery of the fish trade." He then encouraged his fishermen parishioners to take their catch to market themselves and eliminate the Boston-based middlemen who were receiving most of the financial benefit at this point. Barnard had few takers; most felt it was beyond them. One young man, however, Joseph Swett, took up Barnard's idea and began to organize his own ships.[85] His first cargo ship was sent to Barbados and soon after he was trading with European ports as well. Many others followed his example, Barnard noted, and this jump-started the Marblehead economy. "Let God have praise," he wrote, "who had redeemed the town from a state of bondage into a state of liberty and freedom."[86] From this last statement, one might think he was referring to the cause of the Revolution, which began several years after his death. But it cannot be forgotten just how depressed the local economy was at the time of Barnard's arrival in the town. During his tenure, Marblehead reached its greatest economic heights and clearly had its "golden age."

Although Barnard may have had less animosity toward the town's Anglican church than the Mathers would have liked, he did do his share of meddling in their affairs. Barnard chronicled his relationships with several of St. Michael's rectors over the years. He said of the very first rector, Mr. Shaw, "I found him neither a scholar nor a gentleman, but a poor, mean bigot, with whom we could have no intimate correspondence; of such behavior that he was forced to run away from his people in a few years."[87]

Barnard had a more harmonious relationship with the church's second rector, David Masson, and he asked Masson why he was so warm to him and other Congregationalists. The rector replied,

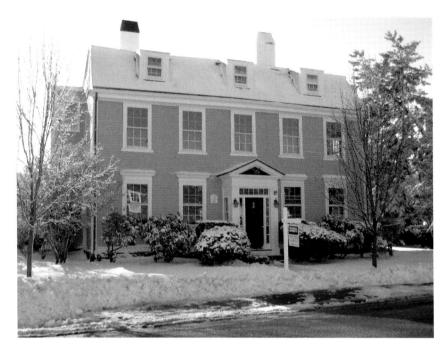

The Reverend John Barnard lived in this house on Franklin Street. *Photo by Lauren Fogle.*

> *Why sir, you must not wonder at it, when you consider that before I came over to you, I was filled with the conception of you as an heathenish, irreligious people, full of spleen and rancor against the Church of England; but when I had been among you for some time, I found you a virtuous, religious, civilized people, and of moderate temper towards the church; and therefore I thought proper to alter my conduct.*[88]

As the rector's reply surely demonstrates, the misconceptions, distrust and suspicion went both ways. Barnard's own relative tolerance of the Anglicans may have separated him from some of the less liberal-minded Congregationalists, but it ultimately helped ease the social discord in Marblehead. Barnard disliked discord; one might even go so far as to suggest that it frightened him. He made efforts with all the Anglican rectors, and there were four in the early years of the church.[89] When he heard that a certain Mr. Checkley had gone to England to take orders with the purpose of returning to Marblehead to preach at St. Michael's, Barnard decided to write to the bishop of London to attempt to swing favor against Checkley, who he felt was "an enemy to the churches of this country." Soliciting Reverend Holyoke as a co-writer, he then sent the letter to an associate in London

Daily Life: The Market

From the mid-eighteenth century, Marblehead had a food market on the lower floor of the town house. Town records show that it was open Tuesday and Thursday from sunrise until one o'clock in the afternoon and on Saturdays from sunrise to sunset. There were several rules regarding the types of produce and meats that could be sold there and a clerk was appointed to make sure that these market regulations were upheld. If they were not complied with, the offender would be fined and that sum donated to the town's poor. The market was a place where people sold and bought, but also gossiped, socialized and conducted business. Since the town pump was located at the northeast corner of the town house after 1763, this site was undoubtedly one of colonial Marblehead's social centers.

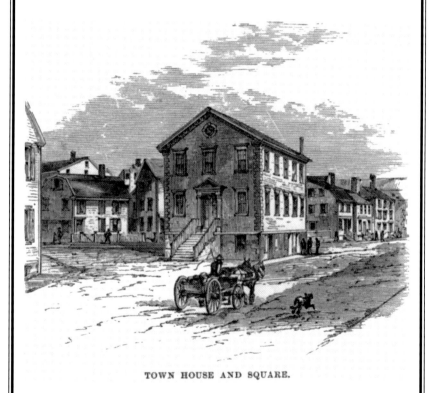

TOWN HOUSE AND SQUARE.

The town house, Marblehead. *Courtesy of the Marblehead Museum and Historical Society.*

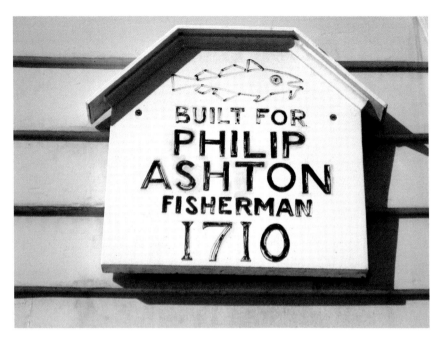

Philip Ashton's house, built in 1710, still stands at the corner of Elm and Mugford Streets. *Photo by Lauren Fogle.*

with instructions to give it to the bishop if it was acceptable to do so, or otherwise destroy it. The letter was passed on to the bishop, who ultimately replied that they would find "a good man, of catholic temper, and loyal to the Government." It was implied that this man would *not* be Checkley and the bishop later decided to deny him orders.[90] Barnard was thrilled with the outcome. He wrote, "Thus our town and the churches of this province, through the favor of God, got rid of a turbulent, vexatious and persecuting-spirited Non-juror."[91] Turbulence, it turned out, was something Barnard detested and would make any attempt to avoid. Summing up his ministry in Marblehead, he wrote:

> *My church and congregation have once or twice been in danger of being thrown into a controversy; but a good and a wise God has been pleased so to direct me, in the management of the affairs, that the fire has been quenched before it broke out into a flame; though I had some of the chief and stubbornest spirits to deal with; and now for more than one and fifty years we have enjoyed peace and unity among us, as any church in the country.*[92]

Certainly Barnard had a long and successful tenure; by 1749, he noted that there were only three living male members of his congregation who had been alive when he first became minister. He boasted in his autobiography that he had only been sick twice in his career, during which times his parishioners attended the Second Church instead. His main talent was his understanding of his core audience. He was able to communicate his religious ideals in terms his local congregants would not only understand, but relate to. He even wrote and had published a book in 1725 about the adventures of a Marblehead seaman, Philip Ashton, who was captured by pirates but escaped and was stranded on a Caribbean island, returning to Marblehead years later. *Ashton's Memorial* was dedicated to his "fishing tribe" at Marblehead, whose own trials, fears and successes Barnard adopted and made his own.[93]

The New Lights

It is quite certain that one of the "controversies" that Barnard alluded to in his autobiography was the fervor of the Great Awakening, or the New Lights, as those who participated in it were often called. This was a spiritual revival that took place in Great Britain and the American colonies in the 1730s, '40s and '50s. It began in Northampton, Massachusetts, when the minister Jonathan Edwards began giving intense, evangelical-type sermons. It spread throughout the colonies, but in Massachusetts it was predominantly the Congregationalists who participated. The feverish sermons and frenzied group prayer that epitomized the revival were in stark contrast with the solemn church experience of most Congregational churches in New England. Crowds of people amassed outside churches, town halls, homes and many other public places in order to hear the various evangelists, who traveled from town to town. In particular, groups of middle- and lower-class women found a voice and a vocation during this revival and were some of the most active participants. They formed and led prayer groups. They congregated in great numbers to hear the sermons and were often extremely affected by them. At first, the Congregationalist establishment accepted these revivals and did little to thwart them. However, there were many who were concerned about these New Lights. Marbleheader Nathan Bowen wrote vociferously on this subject in his journal:

> *This town seems Infatuated about what ye people Call Religion, some of ye fisherman & others of ye like powers pretend to Extreordanary*

Gifts! One of them (namely F. Salter) has Set up a Meeting for Evening Devotion & is attended by Crowds of women etc. I hear yet a womans meeting is on foot, & to my great Wonder these practices are Encouraged from the Pulpit by Mr. Bradstreet, tho I should think they Tend directly to subvert ye Good order in society, which its his Regular office to maintain. I expect the Dissenting Clergy will ferment these practices, til they end in the Destruction of their Kingdom & a more general & happy Introduction of our Mother Church of England, which (happy for ye people) admits of no such Confusion.[94]

Bowen was a member of the Second Church, but left and joined St. Michael's when the evangelism became apparent amongst the Congregationalists. He defected to a religious structure that was set, solid and unbending. But in the following passage, he hits directly on what eventually persuaded the Congregationalists to attempt to calm the furor.

This Town seems to be going Distracted after one Rhodes & other mean people who pretend to an Extreordy shair of ye spiret by force where of they draw together the Giddy Mobb & of silly women in great Multitudes to these they have the Impudence to denounce Damnation… have thereby thrown some of ye weakest of ye pupils in to Swounds… which they say, is a Shrude Sign of your Conversion! O, Striped Ignorance! What most surprises me, is yet ye Clergy to many of you are weak enough to be so Infatuated by this new Light so-Called, as to propegate it at ye greatest risqué of their Livings & Bread, for who would pay a preacher £400 per annum when we can have them (such as they are) for nothing?[95]

Bowen made the point that must have eventually dawned on ministers like Barnard. If the people began to trust nontraditional ministers to preach to them the word of God, then why would they continue to support, both financially and socially, the Harvard-educated ministers of the Congregational Church? In other words, could anyone now be a preacher? Bowen seethed when "seven Carters Coblers & ye many Labourers leave their Honest Imployments & Turn Teachers." When this happens, Bowen decided, a town could arrive at something not unlike "worm wood & ye Gall of 1692." To acquaint this revival with the Salem witch hunt is no small thing on Bowen's part. No doubt, large groups of women swooning and screaming is what brought on the association, but a sinister association it is nonetheless. Bowen also acquainted the New Lights with a comet that was visible in the sky around this time and "brought Terror on ye Ignorant

world."[96] Bowen's prejudice against the lower classes and women is perhaps not surprising for a man of means in the mid-eighteenth century. What *is* surprising is how the Marblehead ministers, and many members of the local elite, supported the revival for most of its duration.

The Great Awakening affected Marblehead mostly in the years from 1738 to 1742. During this time, Simon Bradstreet was the minister of the Second Church, having replaced Holyoke when he left to become president of Harvard. Bradstreet saw a large influx of new members to his church during this four-year period; seventy-nine new members, to be precise. This created a congregation nearly twice as large as the one he had inherited from Holyoke in 1737.[97] Barnard still had a larger congregation, but the Second Church's growth during the revival is illuminating. Heyrman's analysis of Marblehead's revival found that Barnard and Bradstreet's support and encouragement of this new form of lay piety actually led to a strengthening of the Congregationalist structure, not a splintering of it. In some other towns, revivalists broke with the Congregationalist Church and formed Baptist or other churches, and some even joined the Anglicans. But in Marblehead, the

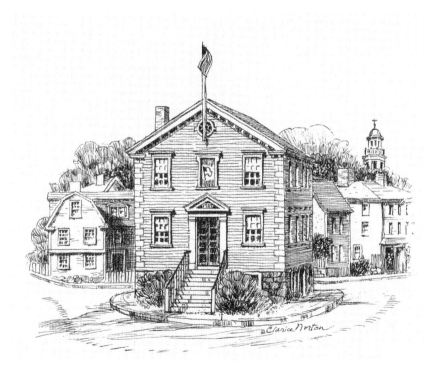

The town house, with Nathan Bowen's house visible on the left. *Pen and ink drawing by Clarice Norton.*

New Lights served only to bolster the Congregationalist orthodoxy, amongst the elite and poor alike.[98] Basically, people became reinvigorated about religion and flocked to Barnard and Bradstreet's meetinghouses in record numbers. Perhaps Bowen's aversion to the New Lights, being a new Anglican himself, is now more understandable.

However, most movements eventually come to an end, and it was no different with the Great Awakening. To be sure, the revival had greatly enhanced the Second Church's status in the town. Not only did membership increase, including a large number of women, but a number of Second Church members were elected to town government during and just after the revival.[99] However, Barnard, as always, had his hands on the controls. He began to encourage a calmer, quieter form of worship, and Bradstreet followed his lead. Together they signed the *Testimony*, which was a document written with other Congregationalist ministers who sought to dampen the revival's heat. Barnard took full credit in his autobiography:

> *In the time of the Whitfieldian ferment, in 1741, I was enabled, by the grace of God, so to conduct, as not only to preserve my own flock in peace and quietness, but to prevent the other church in town, and their minister, from being thrown into the like disorders and confusions, in which so many towns and churches in the country were involved.*[100]

Soon after the cooling, Barnard delivered a lecture in Boston, "Zeal for Good Works," in which he castigated the revival's excesses (which were most apparent toward the end, in 1742). He later wrote of the sermon's popularity. It was "checking the many disorders in several places" and his phrase, "zeal guided by knowledge, tempered with prudence, and accompanied with charity," was "sounded in the pulpits in Boston, and in the many country churches for months after."[101] By not directly opposing the revival, but instead allowing it and controlling it, Barnard lost few supporters and gained many. But Barnard's love of moderation brings us back to his account of the Second Church's establishment. His omission of any mention of the agreement with St. Michael's, or reference to there being any debate at all between his supporters and Holyoke's, may have been calculated by his desire to forget a tumultuous period in his life. He valued peace and harmony, so we cannot discount Barnard's involvement in the dissolution of the agreement, since he may have found the whole episode too turbulent to include in his autobiography. Certainly, this emphasis on "peace and unity" served Barnard well over the years and brought many new members to his meetinghouse.

The Anglicans, on the other hand, received few converts (save Nathan Bowen) and were more and more marginalized. Hurting their reputation

were the physical assaults perpetrated by a number of Anglicans against their own family members or associates (including the deliberate trampling of a man's wife with his horse). Even George Pigot, St. Michael's third rector, was involved in the beating of a farmer with a whip. The farmer had caught Pigot trespassing on his land and stealing his corn.[102] Needless to say, Pigot's situation did not help the Anglican image in Marblehead. Despite this, the Anglicans represented roughly 20 percent of the Marblehead community, too small to be of great consequence but too large to be ignored. In general, post-revival Marblehead, led by Barnard, was a tolerant religious environment. Local upheaval, whether of a social, economic or religious nature, was becoming a rarer occurrence.

Daily Life: A Perilous Existence

Life in eighteenth-century Marblehead was not easy for the majority of townspeople, but it could also be incredibly dangerous. Common household accidents, as well as mishaps on ships at sea, were often fatal. A few examples from the journals of Nathan, Ashley and Edward Bowen and the *Essex Gazette*: One woman fell into her own hearth and was burned to death; a young boy working on a ship fell from atop the mast and "dashed his brains out"; a man fell down a well and drowned (he was the second person to drown in the same well). In what may have been an accident, a three-day-old baby was also found drowned in a town well. While this baby may or may not have been a victim of infanticide (which was not uncommon; there were two reported in one edition of the *Essex Gazette* in April/May of 1772), many other children died young from a variety of ailments, most of which are today considered benign. For example, one of Ashley Bowen's sons died at four months because he was born with a cleft palate. In neighboring Salem, from January 1, 1769, to January 1, 1770, the following died: fifty-two infants/toddlers under the age of two, eight children under the age of five and two under the age of ten. As for the adults, fifty-three died, fourteen of whom were over the age of seventy. Of all the deaths, fluxes, consumption and fevers killed the most, followed by chronic diseases, "sudden death" and a combination of jaundice, dropsy, palsy, rheumatism and one from "jaw lock." These statistics are likely typical for Marblehead in this period as well. However, only one person was reported drowned in Salem that year, while it is probable that considerably more drownings

occurred in Marblehead due to the increased maritime activity. One Marblehead man died after being fished out of the sea near Gray's Wharf; another died after he disembarked from his vessel and fell through the ice in the harbor. Drownings aside, a Marblehead skipper and a member of his crew both died suddenly and mysteriously one night in the summer of 1771. An inquest found that they died from drinking an excess of rum (one quart). It is important to note that in many cases of illness or accident, the nearest doctor could be hours away. When Ashley Bowen's wife was ill, their doctor came from Andover. Bowen's recording of his frequent trips to Boxford indicate that it took him about eight hours to make the journey, and therefore a trip from Andover might have been even longer.

THE GREAT DISTEMPER
Smallpox and Inoculation

Everyone living on the continent of North America, regardless of race or ethnic background, lived in fear of smallpox in the colonial period. It was responsible for millions of deaths in Central and South America in the sixteenth and seventeenth centuries and it is estimated that up to 90 percent of the Native American tribes of Massachusetts Bay Colony died from the disease. The first major outbreak in Marblehead was in 1730, and in order to protect themselves from the contagion, which began its spread in Boston, the Marbleheaders built a fence at the entrance of the town and patrolled it every day and night. The sick were isolated; Native Americans and black and mixed-race slaves were forbidden to walk the streets after nine o'clock at night; all roaming or homeless dogs were shot; and the ferry to Salem was discontinued. The fear, however misdirected, was understandable given the high mortality rate (up to 30 percent) and the knowledge that nothing short of completely closing Marblehead to all boats would keep the town safe from the disease. It is not known how exactly smallpox spread to the town, but it most likely arrived aboard a ship. The first reported Marblehead case was Hannah Waters in October of 1730. The precise number of victims from Marblehead was not recorded, although only two of the town's selectmen were still alive by the following summer.[103]

When the Cure Is Worse than the Disease:
The Anti-Inoculation Riot

Aside from isolating the sick and curtailing travel to and from infected areas, there was little anyone could do to stop the spread of smallpox in the eighteenth century. However, a new preventive process was being introduced throughout the colonies: inoculation. Inoculation was a controversial strategy

that entailed giving a healthy person a mild case of the disease so that he would survive the infection and be immune to smallpox in the future. Since this option had a 0.5 to 2 percent mortality rate, much lower than the average death rate for smallpox itself, it was growing in popularity. However, as John Adams put it in 1764,

> *Do not conclude from any Thing I have written that I think Inoculation a light matter—A long and total abstinence from everything in Nature that has any Taste; two long heavy Vomits, one heavy Cathartick, four and twenty Mercurial and Antimonial Pills, and, Three weeks of Close Confinement to an House, are, according to my Estimation, no small matters.*[104]

There is no question that this was a risky strategy; inoculations could be successful, but patients were contagious for a time after the procedure and keeping them quarantined was essential. Inoculation was also expensive, and therefore it was not readily available to all strata of society. During a minor smallpox outbreak in Marblehead, in 1721, the town had called a meeting and decided that no inoculations were to be done in the town whatsoever. In fact, no person who had been inoculated and no doctor favoring that treatment was to be admitted into Marblehead.[105] However, when the second epidemic arrived in 1730, the town decided not to outlaw inoculation completely, since the potential of the procedure had become evident, especially in Boston.[106] There were many amongst the Marblehead elite, including Reverend Edward Holyoke of the Second Church, who believed in inoculation and escaped to Boston for treatment.[107] But the rising number of infected persons, and therefore the mounting deaths, turned many Marbleheaders against inoculation. The crux of the fear was this: those who were inoculated were then potentially able to transmit the disease to those who had not been inoculated. Without proper isolation of the inoculated, the spread of the disease could quicken. Since inoculating the entire town population was unfeasible and unaffordable, inoculation was outlawed in Marblehead (though continued in Boston). Those with the will and the means continued to inoculate themselves by traveling to Boston and staying for a while. This very act set off a reaction in Marblehead that came close to igniting the entire town.

On December 7, 1730, Elias Waters, a Marblehead shopkeeper, overheard a conversation between Stephen Minot Jr., a Marblehead justice of the peace, and another townsperson. Waters claimed that he heard Minot utter his desire to inoculate his entire family, if it were not for the fact that his wife was pregnant. Three days later, the town's schoolmaster, Richard Dana, whom

many in town knew had himself been inoculated back in 1721, ran in search of Minot at a local tavern to alert him, and anyone else who would listen, that a group of fifty armed men had gathered at his (Dana's) house and had threatened to tear it down. Soon after his announcement, another message came via Nathan Bowen. Bowen explained that the mob had changed venues and was now bent on attacking Minot's house. Clearly Minot's conversation of a few days before had become public knowledge.

Minot rushed home with several others, only to witness over two hundred people mustered outside his house, many armed with clubs and bats. Minot and the town sheriff, Joseph Blaney, attempted to quell the crowd by demanding to know why they had gathered, but several men became abusive and hurled insults and threats. Eventually, other townsmen came to Minot's defense and managed to bring several members of the mob inside Minot's home, along with Minot himself, who had been busy writing down the names of the rioters. Sheriff Blaney remained at the gate, he too writing down names, until most of the crowd retreated to the town house, just down the road. Almost immediately, another group of about fifty men descended on Minot's house from a different direction and demanded the release of the men held inside Minot's home. The sheriff had little luck dissuading them from their purpose, as they saw his involvement as meddling in something that was not his business. Minot, fearing a full-scale riot, decided to call in the militia. This was nonsensical, since the main leaders of the militia were currently outside his home leading the mob. Adding insult to injury, several captains of the militia did appear at Minot's house later in the evening and asked the justice what he wanted with them. Incredulous, and still unaware that the majority of the militia was against him, Minot replied that he was in great danger. One captain was willing to help disperse the crowd on the condition that the prisoners held in Minot's home be released to him on bail and taken to another location. Minot reluctantly agreed and the prisoners were transferred to the house of a local constable, Richard James. Peace was restored to the night, but the following day a crowd of fishermen, fifty to one hundred in strength, stormed James's house and released the prisoners. James himself was knocked unconscious in the fray and the mob did not finally disperse until Sheriff Blaney arrived.

In the aftermath, only one man, Richard Meek, was successfully prosecuted in the Essex County courts for his part in the December 19 riot. Three others were acquitted, and only two of the sizable number who stormed Richard James's house to release the prisoners were convicted of breaching the peace. The three who were found guilty of an offense were not imprisoned but forced only to pay their court costs, despite the fact that Justice Minot presided in part at both of the trials.[108] Clearly, the majority

of Marbleheaders were on the side of the rioters. But their opposition to Minot and the other pro-inoculation members of the community went far beyond the fear of smallpox. Those who favored inoculation tended to be three things: wealthy members of Marblehead's new elite, patrons of the Second Church and newcomers to town (i.e., not descendants of the original community of settlers). Minot's crowd was made up of mainly transplants from Boston who maintained their connections to the city most seriously. Many of Marblehead's poorer but older families saw this not as a loyalty to one's birthplace, but as a lack of loyalty to the town in which they were currently living. With extremely few exceptions, these new elites attended the Second Church and, as was shown in the previous chapter, the members of the First Church viewed those of the Second Church as opportunists who wanted their own way and were prepared to walk over their fellow Marbleheaders to achieve it. In fact, achievement was not difficult for them; many of the newcomers held offices and positions of status in the community (like Minot, a justice of the peace). Therefore, the mob's mentality, if it can be called that, was to revolt against a group of townspeople who had betrayed them in the past, and would betray them again. It was this public perception, that the newcomers did not care about Marblehead as a whole and would sacrifice the town's well-being to save themselves, that really stoked the fire.

However, there is another interesting wrinkle. The vast majority of the known rioters were not members of the First Church, but of St. Michael's. Though the Anglicans were known for roughhousing and violent outbursts, it was not usually their role to oppose the newcomers of the Second Church. Nevertheless, the uprising could be seen as payback for the newcomers' insistence on a Second Church in the first place, which pleased neither the members of the First Church nor the Anglicans. Plus, opposition to the newcomers, who were seen as ruling Marblehead to the detriment of many others, had taken on a bigger significance and the members of St. Michael's wanted to be a part of that. Town solidarity trumped the family ties between St. Michael's and the Second Church and the Anglicans may have felt they bettered their image by fueling this riot. While Barnard, who had himself favored inoculation, had repeatedly aligned the Anglicans with the outsider force and insinuated that their allegiance to the Church of England equated a lack of allegiance to Marblehead, the Anglicans could now say they were on the right side of the debate. Their perceptions of image were quite correct. In the town election two months after the riot, the Anglicans won three of the five open selectmen seats.[109] Reverend Holyoke of the Second Church missed the riot because he had once again fled to Boston to wait out the smallpox outbreak there. Barnard stayed in Marblehead, bent on

him that he placed two pieces of artillery in his front room, aimed down at the street.[125]

After several new cases of smallpox were reported in town, possibly as many as twenty-two, the proprietors relented and closed the hospital. Many townspeople did not believe that the hospital was indeed closed, and on January 26 a group of men, some in disguise, traveled to Cat Island and burned down the hospital and adjacent barns. What is more, they did so as the three members of the committee who had been chosen to inspect clothing and furniture were sleeping inside the hospital with their families. A total of eleven people escaped the flames, many with little clothing on against the January cold. The arsonists struck down one man with an andiron as he tried to flee the fire. A woman who was nursing an infant managed to escape to the smokehouse, but fainted several times in the process. No deaths were reported as a result of the fire, but the hospital was completely destroyed and the proprietors lost around £2,000, an enormous sum at the time.[126] News of the fire traveled fast and by February 15, the committee of the general court came to Marblehead to "enquire into the grounds of the uneasiness subsisting there."[127]

Despite the *Essex Gazette*'s account that twenty men went to the island to attack the hospital, only two men were ever accused of arson. John Watts and John Guillard were arrested and taken to the Salem jail. On February 25, groups of Marbleheaders (mainly fishermen) gathered and marched to Salem with the intention of freeing the men from the jail. Armed with clubs and sticks, as many as four to five hundred men stormed the jailhouse, overwhelmed the guards and escorted Watts and Guillard back to Marblehead. Three days later, the sheriff of Salem had mustered a band of his own, five hundred strong, and marched toward Marblehead to retrieve the escaped prisoners. Hearing of this, an even larger number of Marbleheaders gathered to repel the Salem marchers. Seeking to avoid a battle, the proprietors of the hospital intervened and announced their decision to drop the charges against the two arsonists. They officially withdrew their suit on the first of March.[128]

Major crisis averted, one might think that the affair of "Castle Pox" was over. However, John Clark, one of the same men who was tarred and feathered for stealing clothes from the hospital, returned to Cat Island and stole more clothes from the charred ruins. He again brought them into the town, where he was apprehended and the clothes were sent to Ferry for examination. The townspeople surrounded him and threatened him with bodily harm until the selectmen intervened and sent him home, promising the gathered crowd that he would be punished in due course. But the people had begun to see the benefits of seeking their own justice and a

mob of twenty or so dragged Clark from his house that night and tied him to the town whipping post. He was badly beaten and afterward made an official complaint to the justices of the Inferior Court at Ipswich. One of the accused attackers, Robert Smith, was arrested and imprisoned, but the others remained largely unidentified.[129]

The rioting and violence of 1773–74 may have stemmed from some of the same fears and angers as that of 1730, since it was a group of elites who opened the hospital and therefore made Marblehead an inoculation center in the region. The poorer inhabitants, usually represented by the fishermen, would not sit idly while the elites put their families in danger by turning their town into a portal for smallpox. The hospital proprietors (John and Jonathan Glover, Elbridge Gerry and Azor Orne) were well-respected men in Marblehead, but had not yet made themselves into legends—their actions during and after the Revolution would do that. The tensions of 1730 had not completely dissipated by 1773; if anything, they had grown stronger.

Even after the outbreak of 1773 finally died down in the following year, smallpox remained a constant threat. During the Revolution, Ashley Bowen worked as a cleaner and disinfector on a ship that had been contaminated with the disease. All ships suspected of carrying infected persons or goods were sent to an isolation hospital on Rainsford Island in Boston Harbor.[130] Bowen and his fellow workers rubbed the decks with vinegar, smoked and even burned parts of the ship in order to kill the virus.[131] When another outbreak unleashed in 1777, the fences went up, the sick were removed to the Neck and Dr. Hall Jackson returned to town. He inoculated almost 450 people and there were no reports of protests or violence.[132] Perhaps the townspeople were too preoccupied with the war to pay attention to the doctor's exploits, or perhaps inoculation had finally turned the corner from risky procedure to lifesaving breakthrough in the eyes of the public.

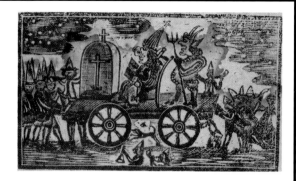

Image of a Pope's Day procession, from an eighteenth-century Boston newspaper. *Courtesy of the Library of Congress, American Memory Collection.*

Daily Life: Bonfire Night

One of the most unique celebrations in colonial Marblehead was Pope's Day, November 5. Many in the colonies observed Pope's Day, which was the American equivalent of Guy Fawkes's Day in England. Guy Fawkes, a member of the "Gun Powder Plot" to blow up the English Parliament buildings in 1605, was (and still is by some) burned in effigy and carried around the towns in parades. The colonists did the same thing, but they carried a pope instead and often a devil as well. This clearly anti-Catholic festival became a showdown between the north and south ends of Boston during the eighteenth century, both sides attempting to capture and destroy the other side's pope. Some have suggested that this ritual was an early form of political street theatre. Ashley Bowen recorded that in 1773 the inmates of the inoculation hospital on Cat Island celebrated the night with a gigantic bonfire and an "illumination" of the hospital. In many places, the custom died out during the Revolution as the colonists found more immediate villains to rail against. However, according to the *Portsmouth Daily Evening Times* (November 1892), the tradition lived on in places like Marblehead and Portsmouth, New Hampshire, until the late nineteenth century, though the participants were mainly young men and boys who "with horns dance in fantastic glee."

BOOMTOWN
The Rise of the Eighteenth-century Port

I f there was one thing that depressed the colonial fishing trade more than any other, it was war. The second in a series of wars between France and England, known as Queen Anne's War to the colonists and the War of Spanish Succession to the Europeans, began in 1702 and greatly affected Marblehead's ability to catch and sell fish. When the fishing schooners did risk the dangerous waters, the fishermen and their vessels were often pressed into naval service by the French. In addition, the town was forced to spend extra money on fortifications to repel a possible French invasion. It was not until the Treaty of Utrecht ended the war in 1713 that Marblehead began to rebuild and expand its fisheries.[133]

The early eighteenth century was a period of great population growth in Marblehead, fed by large numbers of immigrants from the Channel Islands, Scotland, Ireland, England and Newfoundland. At least 80 new names appeared in the church records between 1680 and 1710, though this is clearly only a percentage of the people who came to the town. These newcomers poured into town in even greater numbers after the end of the war with France in 1713; 250 new names appeared in the church records in subsequent years. By 1730, Marblehead's population was approximately 2,000, nearly the size of Salem.[134] Again, as had always been the case, the influx of "outsiders" to the town helped to destabilize the community and create social turbulence that was more often than not exhibited in the county courts. Itinerant fishermen, some residing in Marblehead just long enough to realize that they were not going to be able to support themselves and/or their families there, moved on continually, leaving debts unpaid to angry shopkeepers and tavern owners. Those who stayed found the old Marbleheaders, those whose families had been around for a generation or two, to be fairly prejudiced, especially with regard to immigrants from Jersey. These ethnic and economic tensions made Marblehead just as

rough a place as it was in the earliest days, though now there were far more people living in the town. Heyrman's analysis of the Court of Common Pleas shows that between 1716 and 1738, Marblehead had twice as many people accused of a violent crime than Salem and three times as many for burglary or other crimes involving stolen property or goods.[135] There were also many brawls, both in taverns and on ships, and only a percentage of the details ever reached the courts, usually when there was substantial damage to property involved. In 1723, after a night of drinking, some fishermen smashed the windows of homes and shops, raided a barn and destroyed a carriage.[136]

The Growing Trade

Once Britain had reestablished control over much of the waters in the north Atlantic, local ships had the freedom to travel farther and catch an ever-increasing amount of fish. By the late 1720s, Marblehead's fishing fleet had grown to over one hundred vessels, with nearly twenty British trading ships sitting in the harbor on a given day.[137] As many as six hundred men and boys, close to the entire adult male population of the town, were employed in the fishing trade.[138] Visitors to Marblehead were clearly impressed by the scale of the fishing operation. Dr. Alexander Hamilton, a Scottish immigrant (not the future Treasury secretary), came to town in 1744 and made the following observation:

> It [Marblehead] *contains about 5,000 inhabitants and their commodity is fish. There is round the town about 200 acres of land covered with fish-flakes, upon which they dry their cod. There are ninety fishing sloops always employed, and they deal for 34,000 pounds sterling prime cost in fish yearly, bringing in 30,000 quintals—a quintal being one hundred-weight dried fish, which is 3,000,000 pounds' weight, a great quantity of that commodity.*[139]

Exporting cod would always be Marblehead's staple business. By the 1740s, Marblehead boats accounted for about one-third of the total fishing fleet of the colony.[140] By 1773, the customs district of Salem and Marblehead (which was dominated by Marblehead) exported 119,000 quintals of fish, compared with Boston's 115,000.[141] However, it was the eruption of foreign trade in goods other than fish that really pushed Marblehead to the forefront of the New England ports and created a gentrified merchant class. As seen in chapter one, foreign trade began shortly after Marblehead was founded. Ships went to and from the Caribbean with fish and molasses.

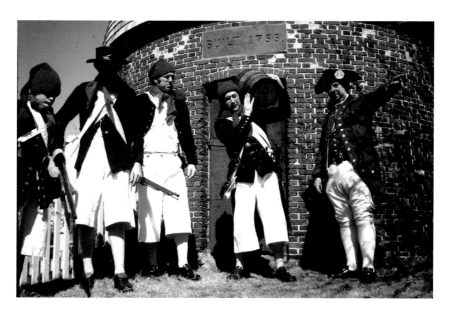

1. Glover's regiment reenactors at the powder house on Green Street. *Photo by John Fogle.*

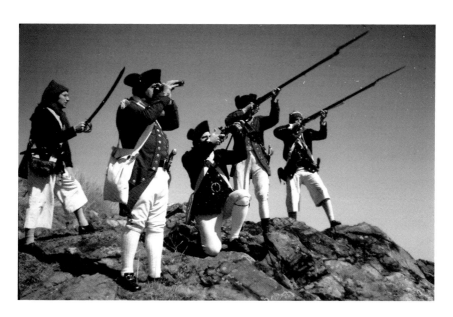

2. Glover's regiment reenactors at Fort Sewall. *Photo by John Fogle.*

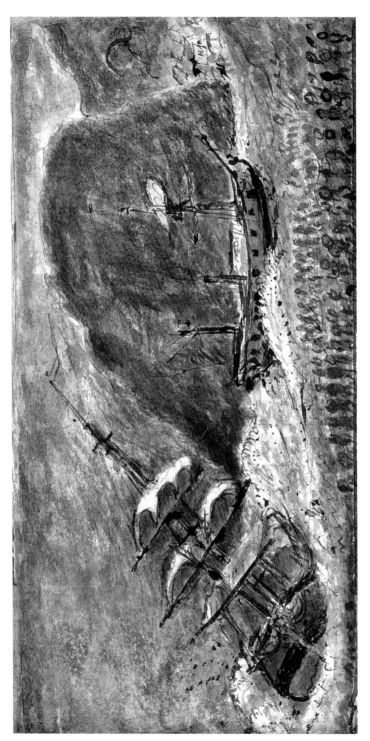

3. Two trading vessels wrecked off the Spanish coast; original drawing by Ashley Bowen, 1750. *Courtesy of the Marblehead Museum and Historical Society.*

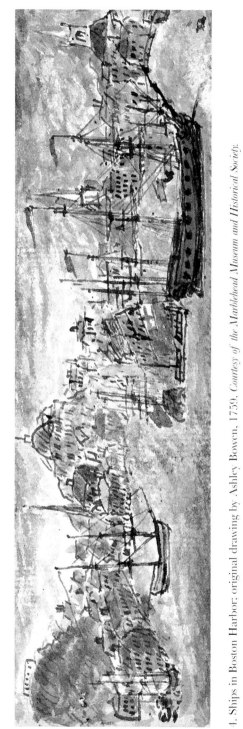

4. Ships in Boston Harbor; original drawing by Ashley Bowen, 1759. *Courtesy of the Marblehead Museum and Historical Society.*

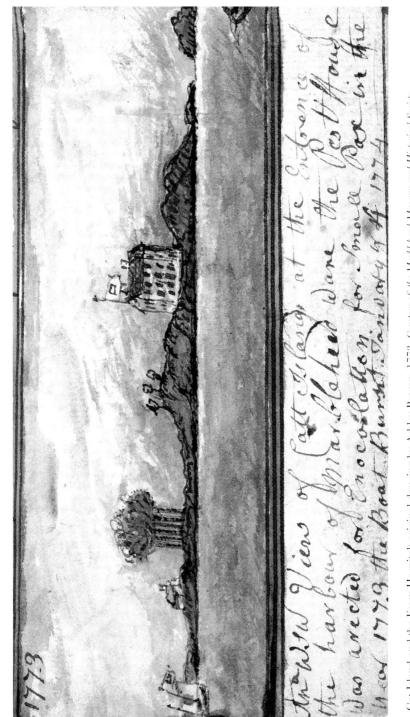

5. Cat Island and the Essex Hospital; original drawing by Ashley Bowen, 1773. *Courtesy of the Marblehead Museum and Historical Society.*

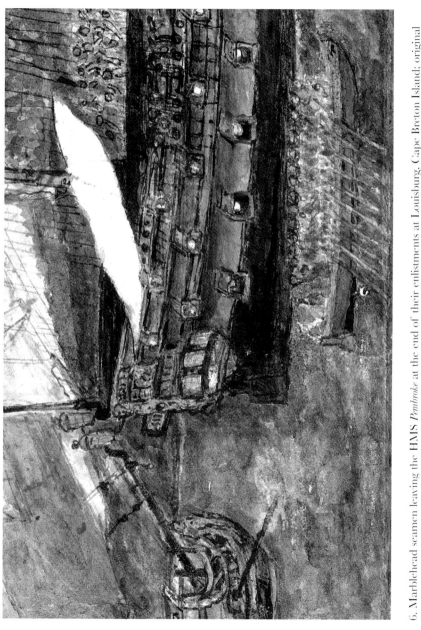

6. Marblehead seamen leaving the HMS *Pembroke* at the end of their enlistments at Louisburg, Cape Breton Island; original drawing by Ashley Bowen, 1759. *Courtesy of the Marblehead Museum and Historical Society.*

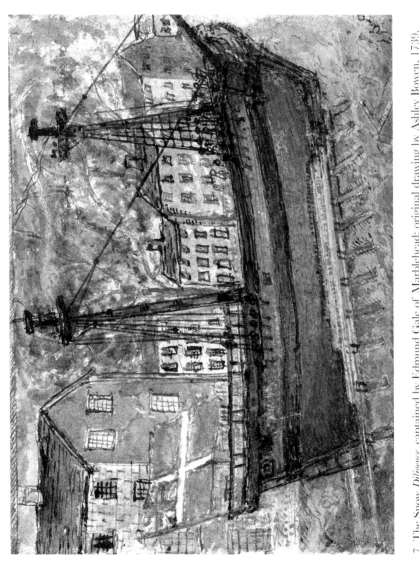

7. The Snow *Diligence*, captained by Edmund Gale of Marblehead; original drawing by Ashley Bowen, 1759. *Courtesy of the Marblehead Museum and Historical Society.*

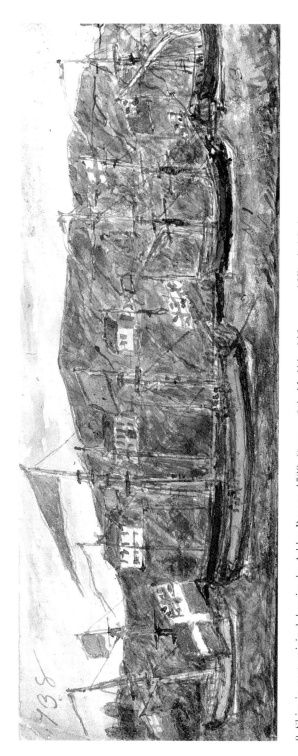

8. Ships in port; original drawing by Ashley Bowen, 1738. *Courtesy of the Marblehead Museum and Historical Society.*

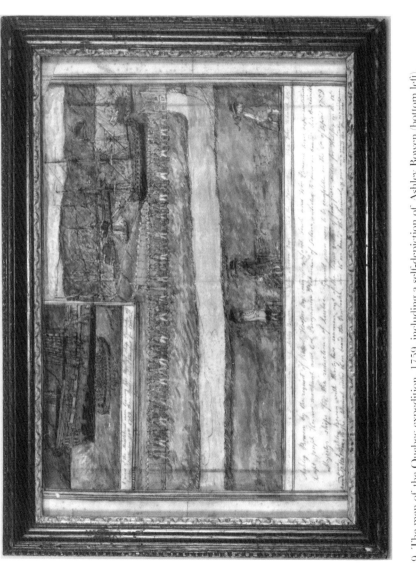

9. The men of the Quebec expedition, 1759, including a self-depiction of Ashley Bowen (bottom left). *Courtesy of the Marblehead Museum and Historical Society.*

A destructive storm in 1694, combined with the natural passing of many of the original merchants and boat builders, quelled Marblehead's foreign trade and induced a nearly thirty-year period of economic depression.[112] However, perhaps due to the urgings of Reverend Barnard, foreign trade did resurge in the middle of the eighteenth century and new trade routes and cargo emerged: there were coastal voyages to Philadelphia and the Southern states for produce or naval stores; trips to the Caribbean where fish or New England products were exchanged for rum, sugar and molasses; voyages to Europe where high-grade fish was exchanged in Spain for salt, wine and fruit; and ships sailed to England and brought back Far Eastern textiles like nankeens, calicoes and muslins.[143] Since many of the customs records for Marblehead were destroyed during the Revolution, much of our information on eighteenth-century trading cargo comes from the plentiful law suits filed by various people, often against merchants or sea captains, for the loss or damage of transported goods. One such suit was filed in 1754 for £1,000 worth of damaged goods consisting of:

15 boxes of lemons
1/3 of 51 casks of salt
41 boxes of lemons
100 jars of oil
15 jars of olives
4 quarter casks of oil
10 jars Canary wine
1 piece of cambrick
20 bbls. of Malaga
40 casks of raisins
100 dozen of Barcelona handkerchiefs
465 hogsheads of salt
58 bbls. of salt
10 casks of raisins
70 boxes of lemons
2 quarter casks of wine
76½ milled dollars
293 quintals of Jamaica fish
1 barrel of mackerel
2/5 of 58 lasts of sacks
20 boxes of lemons
4 quarter casks of wine
468 milled dollars[144]

Goods from Spain, the Canary Islands, the Caribbean and the Far East (via London) were all contained in this one shipment into Marblehead Harbor. The shipping manifest for 1752–53 indicates that over half of the thirty-seven Marblehead ships leaving the port were bound for southern Europe.[145] The ships of Thomas Gerry, father of Elbridge, illustrate this point. His fifty-ton schooner *Makepeace* sailed from Marblehead to Cadiz, Bilbao and Lisbon with huge quantities of fish and returned with the salt that would cure the fish for the next year's shipment. Another ship, the *Rockingham*, sailed from Marblehead to Spain in the summer of 1772; discharged fish at Bilbao; took on wine, raisins and lemons at Malaga; discharged a quantity of its cargo at Falmouth, England; and returned to Marblehead via Philadelphia, where she took on flour.[146] By this date, Marblehead was a bigger trading port than Salem, and the biggest in Essex County.[147] Ships from Marblehead brought back not only goods, but news from the rest of the world as well. The *Essex Gazette*, published weekly in Salem between 1768 and 1776, credits many Marblehead ships for bringing back the "advices" from Europe (including London, Spain, France, Holland, Poland, Ireland and Scotland) as well as places farther afield, like Istanbul. The paper also published excerpts from various London broadsheets, all courtesy of the ships that carried them back.

When the Marbleheaders began trading directly with foreign ports, bypassing Boston, they also began to self-finance their own ships and expeditions. That meant greater rewards for the financiers if a shipment arrived safely at its destination, but also greater risk when things went wrong. The war between England and Spain from 1739 to 1742 interrupted trade, though it did not completely dismantle it. Some wars

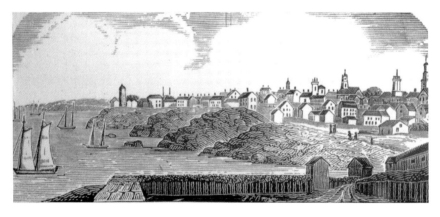

A view of the town and harbor from Fort Sewall. *Courtesy Marblehead Historical Commission, Abbot Hall, Marblehead, MA. http://www.marblehead.com/MHCarchive/index.htm.*

were even popular in Marblehead, like the campaign against the French at Cape Breton Island (Louisburg), because ridding the north Atlantic of a major French presence was a goal of the British and colonists alike.[148] One must keep in mind that wars also affected the maritime trade's staffing, since a number of seamen were pressed into military service each time a new campaign surfaced. In some cases, they went willingly. In 1759, 45 seamen from Marblehead enlisted for the Siege of Quebec, along with 32 other Marbleheaders who enlisted as sailors.[149] Also, even when a war was not raging, the seas were. A storm in 1741 killed so many Marblehead seamen that the town was obliged to ask for tax relief from the general court. The same thing occurred again in 1746, when a quarter of the town's fishing fleet was destroyed in a storm.[150] The years 1768–69 were disastrous: a total of twenty-three Marblehead ships were lost and 122 men and boys died.[151] Despite these setbacks, Marblehead was making money on an unprecedented scale (for the town) and all this wealth did more than just enrich a group of local merchants—it created an entire ruling class and stabilized a society that had already seen its share of turbulence.

Daily Life: The Poor

Due to the dangers of fishing and the prevalence of British and French press gangs, Marblehead had a large number of poor families, widows and fatherless or orphaned children. Many of the poor received financial support from the town (town records show payments of eleven shillings to a widow Slater and two shillings a week to Christopher Hardy until he could maintain himself, among others). However, supporting all the poverty-stricken families in town was not possible, and a workhouse for the poor was built in 1761 on the site of the former "negro" burying ground (located at the corner of Pearl and Elm Streets). After several years, the town selectmen (their official title became "Selectmen, Overseers of the Poor and Workhouse") realized that the inmates of the workhouse needed to get out and find paying jobs. They ordered the town constable to investigate ways to raise or borrow enough money to relieve the suffering of those in the workhouse, who they said would die otherwise. Some wealthier residents, like the merchant Ebenezer Stacy, left money to the poor of the town in their wills. Poor children in Salem were advertised in the *Essex Gazette* as being

available "to be bound out" to someone needing an indentured servant. It is likely that the same thing happened in Marblehead, where the schools only admitted children who could read, which left out most of the poor. A town investigation found that at one point there were 122 Marblehead boys left untaught (girls were not admitted to schools, regardless of reading comprehension). The town then attempted to educate these boys in order to gain them admittance to the town schools; this marked the beginning of primary education. After a particularly damaging year for seafarers, the town would appeal to the great and general court of the colony for financial assistance for the families. Marblehead received just over £117 in 1771. For some this came too late. Timothy Courtis, a poor man with many children, hanged himself in his house in 1770. The court inquest into his death ruled it "self murder" and reported that "what induced him to commit this shocking and unnatural act is not known."

The Marblehead Merchant Class

The shift really began with the departure of several key inhabitants. After the anti-inoculation riot of 1730, a number of prominent but relatively new townsmen left Marblehead and returned to Boston with their families. Among them was Stephen Minot Jr., the justice of the peace whose house was nearly pulled down by a mob of rioters. Several other influential Boston-based families, like the Brattles, died out or also moved back to Boston. The leader of many of these Bostonian-Marbleheaders was Reverend Holyoke, who also left the town to head Harvard College. In general, these elite of the Second Church filled only half of the town offices in the 1730s that they had in the 1720s. By 1748, they represented only a quarter of the richest decile of town taxpayers.[152] It is likely that Marblehead's entrance into direct trade, bypassing the middlemen of Boston, contributed to the flight of those who used to profit from the middleman arrangement.

What emerged after these departures was a class of merchants, over half of whom were members of Barnard's First Church, that controlled a huge proportion of the town's economy and dominated the town government. Among the most successful merchants were the duo Robert Hooper Jr. and Joseph Swett, Jeremiah Lee, Benjamin Marston, Ebenezer Stacy, Benjamin Stacey and Joshua Orne, just to name a few. Some, like Marston, seem to

have dealt primarily in one set of goods, in his case various types of textiles. Jeremiah Lee, whose family was originally from Manchester, became one of the colony's wealthiest men and built a mansion house in Marblehead that remains the town's finest surviving colonial residence.[153] Across the street from Lee's mansion was that of Robert Hooper, "perhaps the richest merchant of his time in New England."[154] Like many of the other wealthy merchants, Hooper kept a country house in Danvers, but Lynn, Topsfield, Beverly, Middleton, Newbury and Boxford were also popular locations for second homes.

These prosperous merchants and their families lived extremely well for most of the eighteenth century. Several inventories are extant from the period and provide lists of the sumptuous furnishings and elegant clothing owned by many of these families. The inventory of Captain Joseph Smethurst, a London mariner who settled in Marblehead and partnered with Benjamin Marston, reveals that he owned three schooners, three houses and a number of fish fences and warehouses. His household furnishings were many, but the highlights include mahogany and Japanned tea tables, two brass hearths, six brass sconces, a dozen walnut leather-bottom chairs,

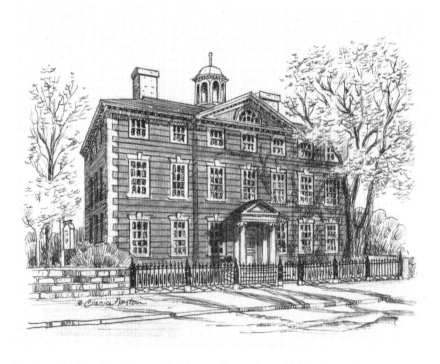

The Jeremiah Lee Mansion on Washington Street. *Pen and ink drawing by Clarice Norton.*

sets of burnt china plates, a walnut couch with a squab (stuffed cushion), Turkish carpets and chairs, a large set of silver (over twenty pieces), ten pictures of the royal family and over ninety pieces of artwork (many of them framed). In addition to imported furniture, linens and works of art, a wealthy merchant would own an impressive amount of fine clothing and shoes. James Skinner, one of Marblehead's representatives to the general court, died in 1747 and among the items in the inventory of his estate were eight coats (some blue, some red), ten jackets, ten pairs of breeches (some velvet), one corduroy suit, twelve neck cloths, six handkerchiefs, fifteen shirts, twenty-two pairs of stockings (some wool, some silk), one pair of boots, five pairs of shoes, four wigs, one cane, two pair of silver buckles, one gown and five caps.[155]

Even in death, these wealthy families spent large amounts of money on clothes and furnishings. The funeral expenses for James's brother, Captain John Skinner, in 1747 reached £1,000 and included payments to doctors, gravediggers and the town bell ringer for tolling the bells. Sixteen mourning rings were made by a local goldsmith and nearly £200 worth of cloth for mourning dress and men's and women's gloves was ordered from Boston.[156]

Heyrman's analysis of Marblehead's new merchant elite found that they obtained their wealth and status by staying involved in their businesses and by working often with each other. They invested in one another's ships and voyages; they extended one another lines of credit; carried one another's letters on journeys; and even contacted foreign associates for favors on one another's behalf. They did not, however, do any of this with outside merchants from other New England towns. They also used mainly local seamen and ship captains and most of their ships were locally built. There was an insular and "competitive spirit," to say the least. Many of the Marblehead merchants were intimately involved with the day-to-day running of their businesses. Swett and Hooper complied with the preferences (some would call them superstitions) of the local fishermen, like not sailing on Fridays, in order to build loyalty. A close relationship between merchants and their captains and seamen made for fewer lawsuits, since there was less hostility.[157] When Parliament instituted an excise tax on goods such as liquors, wines, lemons and oranges in 1754, the Marblehead merchants were united against it, which was understandable considering the contents of their trading cargoes. A town meeting was called to discuss a response. In the end, most joined a petition to the king asking him to reconsider the duty.[158]

This new gentry also felt a keen obligation to the town as a whole—something that previous elites had failed to possess, much to the anger and resentment of the lower classes. In 1747, a school for poor children was

established by Robert Hooper. He also bought a fire engine for the town's newly organized fire department in 1751. This engine was kept on Front Street, near Goodwin's Court, while a second engine, bought by the town and shipped from London, was kept at Newtown Bridge on the corner of Washington and School Streets (now known as Five Corners).[159] This fire department came to the aid of Salem in October of 1774, when a rapidly spreading fire threatened much of the downtown, including the town house. James Duncan Phillips, historian of colonial Salem amongst other things, wrote of the fire:

> *The physical endurance of the Salem folk was fast ebbing away. But Marblehead had seen the fire, and with the same tumultuous energy with which they had joined the smallpox riots, the Marbleheaders came roaring into town some hundreds strong, with two more engines. They manned the engines and filled out the gaps in the bucket lines… Marbleheaders turned the scale and the fire was stopped. The town could well afford to invite the Marbleheaders to breakfast at the tavern, and paid for a hundred and thirty-two breakfasts, three gallons of West India rum, and three of gin!*[160]

Hooper also built a rope factory, known as a ropewalk, on Barnard Street in 1768.[161] Hooper was often referred to as "King" Hooper, a distinction borrowed from the Newfoundlanders who used it "to connote admiration for the entrepreneurial ability of men perceived as permanently connected to local society and capable of maintaining order."[162]

Many of the merchant class also took on positions of responsibility in times of war or maritime disaster. In 1746, a group of merchants created a fund for the families of men lost at sea or dead of disease during the Louisburg expedition. During the Revolution, Thomas Gerry made plans to keep round-the-clock watches at the fort. The following chapter will chronicle the efforts of a number of Marblehead merchants who risked all that they had for the revolutionary cause. This dedication to Marblehead's fortunes crossed over from business, to war, to social and family obligations. Heyrman's analysis of the town's marriage records indicate that fewer than 15 percent of all marriages among the First Church's elite families involved a non-Marblehead spouse. When a Marbleheader did marry someone from outside the town, the outsider was a member of the Hooper or Lee families over half of the time, and most often they married someone from Newbury (where there was also a shipbuilding industry). Boston alliances, popular with the members of the Second Church earlier in the eighteenth century, were now uncommon.[163]

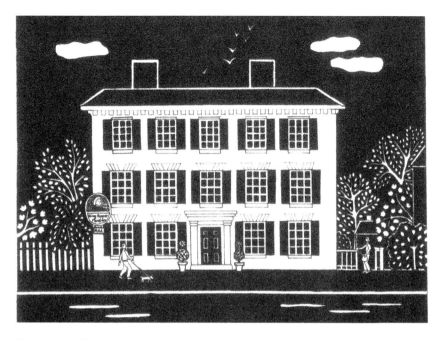

The Robert "King" Hooper Mansion on Hooper Street. *Pen and ink drawing by Polly Maxon Tritschler.*

A Bustling Town

The town grew and benefited in many ways in the eighteenth century, and though not all improvements were due solely to the charity of the merchant class, the influence of the merchants in political, social and economic affairs is undeniable. Marbleheaders enlarged the old meetinghouse in 1724, adding twenty feet to the southeast end, and built an entirely new meetinghouse (now known as the Old Town House) in 1727. In that same year, the town petitioned the Massachusetts General Court for assistance in repairing the harbor (the sea had broken through the causeway in several spots) and for the repair and upgrading of the fort, since no harbor of such "importance and trade is left so wholly unguarded."[164] The next year the jail and cage were finished and located inside the new town house.[165] Due to the ongoing nature of the French and Indian War and the ever-present threat of a French naval attack, Fort Sewall was again re-fortified in 1742. Hamilton, the Scottish visitor, noted, "The town battery, which is built upon a rock, [is] naturally well fortified, and mounts about twelve large guns."[166] The powder house on Green Street was erected in 1755, another preparation for a battle against the French.[167] A second windmill stood on a hill called "ye lower Windmill

hill," which is close to today's High Street, in 1732, but was gone by 1759.[168] By 1768, three new schools had opened, with 160 students at each school. A few years later, even this was not enough and two new schools were built.[169] For those who could afford it, there was even a school where French, music, dancing and fencing lessons were offered. For a fifty-cent entrance fee, a student could be taught these skills by a pair of French brothers who were "thrown into this town by misfortunes" and were attempting to make a living teaching what they knew. They also taught lessons in Salem and charged two dollars per quarter.[170]

The roads were updated too, especially the road to the Neck, which was rebuilt in 1720. Until Pleasant Street was laid out in 1770, Washington Street was the main road in and out of town. Many new roads were laid out in the early and mid-eighteenth century, including quite a few roads that were not directly in the main settlement (i.e., not in "Old Town"), like Roland and Hawkes Streets.[171] John Adams observed the town briefly in 1766, commenting, "Marblehead differs from Salem. The streets are narrow, and rugged, and dirty, but there are some very grand buildings."[172] No doubt he rode past the Lee and Hooper mansions and saw the town house and perhaps the homes of the Gerrys or the Ornes.

FORT SEWALL.

View of Fort Sewall. *Courtesy of the Marblehead Museum and Historical Society.*

For certain, by the second half of the eighteenth century, Marblehead resembled nothing of the dreary town, devoid of craftsmen or merchandise, which Reverend Barnard had described in his autobiography. By his death in 1770, the town had many shops, taverns and craftsmen/artisans offering much of what was popular in London at the time (though on a smaller scale). Edward Griffiths, a tailor of Marblehead, ran an advertisement in the *Essex Gazette* in July of 1768 calling himself "Taylor and Habit-maker from London." Alexander Campbell's Wig and Hair Dressing Shop was up and running by August of 1769, and in the next month Henry Sander's new tavern, Sign of the Green Dragon, was operating near Hooper's Wharf. Benjamin Eaton's apothecary, near the New Wharf (the Landing), advertised a long list of potions and elixirs:

> *Hooper's female pills, which remove all obstructions, bring nature into its proper channel, restore a good appetite and sound digestion; British tooth powder, which cleans the teeth and gums from all foulness and renders them white as ivory; balsam of honey for coughs, colds, consumptions and complaints of the breast; fever powders.*[173]

Thomas Robie began selling "hardware" at his store at the bottom of Training Field Hill (Washington Street) around 1770 and stocked everything from pots and pans to guns, gunpowder and nails. In 1771, John Sparhawk had a shop above the market, in the town house, which sold coffee, spices and all kinds of cloth and clothing.[174] A saddler, John Sorrell, came from London to set up his shop, also above the market, in 1770.[175] He advertised that he "will engage to make any piece of work as complete as can be imported, with Fidelity and Dispatch." This was more than just good advertising; it was a necessity because of the nonimportation agreements, which were a boycott on British goods and will be discussed in the next chapter. Regardless of the reason, the town's boom in trade had brought with it "a small army of joiners, wigmakers, and carpenters [who] appeared to serve the town and supply the trades whose lack Mr. Barnard had deplored."[176]

As the town grew and blossomed economically, the crime rate was lowered and could not compare to that of the seventeenth-century town. Although tavern and ship brawls were still common, as was theft and occasional assaults, reported rapes and murders were rare. One accused man, Brian Sheehan of Salem, was convicted of raping Mrs. Hollowell of Marblehead. He was hanged in January of 1772, after several delays, and the *Essex Gazette* reported that his was the first felony conviction since the "Witch Time" of 1692.[177] This statement is hard to believe, though it shows clearly that the public perception of crime had indeed been reduced.

Daily Life: Extreme Weather

Those who lived in North America and Northern Europe in the seventeenth and eighteenth centuries existed during a time known as the Little Ice Age. The anthropologist Brian M. Fagan wrote in his book *The Little Ice Age: How Climate Made History 1300–1850*, "There was never a monolithic deep freeze, rather a climactic seesaw that swung constantly backwards and forwards, in volatile and sometimes disastrous shifts." The winter temperatures were often brutal and the freezing of Marblehead Harbor, either partially or completely, was a common occurrence. Eight feet of snow reportedly fell in Salem during one winter storm. Ashley Bowen recorded frequently in his journal that the day was "smart cold" and often remarked that no rigging work could be done due to the temperatures. The *Essex Gazette* sometimes reported on the cold and also the drastic temperature changes in the weather experienced during this time. On May 10, 1769, it was 84.5 degrees in the shade, but only 41.5 degrees by the next day at noon. On November 28 of that year, the paper recorded the following temperatures: 13.5 degrees at 11:00 a.m., 7 degrees at 11:00 p.m. and 3 degrees at 8:00 a.m. the following morning. Needless to say, extreme weather made harvesting a crop more difficult and fishing expeditions all the more dangerous. In 1667, the weather was so bad all year that Marblehead's fishing crop was devastated. The town's portion of the county tax was waived that year since the townspeople simply could not pay it. The Marbleheaders did occasionally attempt to thwart Mother Nature by housing their ships at Salem or Danversport during the times of year when Nor'easters were most common.

A Fisherman's Life

A New York City merchant, Captain Francis Goelet, made the following observation of Marblehead in 1750:

> *The Towne of Marblehead, has about 450 Houses all wood and Clapboarded the Generallity Miserable Buildings, Mostly Close in with the Rocks, with Rockey foundations very Craggy and Crasey. The whole*

Towne is Built upon a Rock, which is Heigh and Steep to the water.
The Harbour is Sheltered by an Island, which Runs along Parralell
to it, and brakes of the Sea, Vessells may Ride here Very safe, there is
a path or way downe to the warf which is but Small and on which is
a Large Ware House, where they Land their Fish &c. From this heigh
Cliffty Shore it took its Name, I saw about 5 Topsail Vessells and about
10 Schooners and Sloops in the Harbour, they had then about 70 Sail
Schooners a Fishing, with about 600 men and Boys imployed in the
Fishery, they take Vast Quantities Cod, which they Cure here Saw Several
Thousand Flakes then Cureing. This Place is Noted for Children and
Noureches the most of any Place for its Bigness in North America, it's
Said the Chief Cause is attributed to their feeding on Cods Heads, &c.
which is their Principall Diett. The Greatest Distaste a Person has to this
Place is the Stench of the Fish, the whole Air seem Tainted with it. It
may in Short be Said it's a Dirty Erregular Stincking Place.[178]

The inhabitants who would have best recognized this dirty, crowded Marblehead were the fishermen and their families. Despite the economic boom, most of the town's fishermen had seen only a small standard of living increase. Daniel Vickers combed the inventories of Marblehead fishermen and found that in the mid-eighteenth century they owned slightly more than their seventeenth-century colleagues and their household items were often made of a higher-quality material. Featherbeds became common, as did linen bedding and quilts. Most families could boast a dining table of maple or walnut and as many as twelve chairs. They owned more pewter, brass, iron and glass than those who preceded them, yet very few owned their homes. Despite being fishermen, very few owned their own boats. In all, Vickers found that the average net worth of fishermen went from £13 in the period 1651–75 to £15 in 1751–75, exactly a century later. However, since housing prices (rentals included) rose by a third, the standard of living of the average fisherman changed very little in a century.[179] Part of the problem was that the fishing industry did not work all year round. In the heart of winter, some fishermen doubled as cobblers or were employed in other small-time trades, but many found themselves most often in the taverns, gambling. By the mid-eighteenth century, this had become such a problem that the town instituted a law against gambling, which held a fine of ten shillings.[180] Reverend Barnard attempted to wrench his flock away from sin and corruption; his dedication to a sermon in January of 1749 stated:

I know, my Brethren, that, as for many of you who attend the Business
of the Sea, your Temptations are very many; nevertheless, as I bless GOD

for the Great Reformation of Manners evident unto all Men, and the flourishing Condition of the Town, the happy Fruits of it, so I entreat you to prosecute the more thorow perfecting of that good work, and that you would, each of you for yourselves, be careful to be furnished with that inward Principle, which alone will truly fortify you against Temptations, and support, and strengthen you Vertue.[181]

The trials of the local fishermen had always been there, whether the town was boom or bust. Gambling, it would turn out, was the least of their problems. In the early eighteenth century, a dangerous pattern of debt emerged that kept many fishermen in "a kind of indentured servitude."[182] The fishermen went to their bosses, the shore men, and even to the merchants themselves for loans or advances on wages. They also often paid their tailors, butchers, doctors and liquor purveyors with promises of fish, which they were not always able to keep. As a result, Marblehead developed an extremely litigious society. Though this cycle of debt was nothing new and had been going on ever since the town was settled, it became worse as the merchants got richer and the fishermen poorer. By 1730, nearly 70 percent of all defendants in Marblehead lawsuits were fishermen, shore men or other seamen. Lucky for the fishermen, the laws of the Massachusetts Bay Colony were quite lenient when it came to debtors. Rarely were long prison sentences served after the 1698 Act for Relief and Release of Poor Prisoners for Debt, which allowed a prisoner to sign a "pauper's oath," which declared his worth at under ten pounds, and be released.[183]

The town tried to remedy the poverty by appointing a selectman to oversee the poor and their problems. In 1761, a workhouse for poor was opened on the site of a former slave burial ground.[184] But it was the market, and the need for skilled labor, that ultimately determined many of the indebted fishermen's fates. The merchants and shoremen, often financially bailing the fishermen out of trouble (or literally bailing them out of jail), demanded to be repaid in man hours on their ships.[185] This is how the indentured servitude of the fishermen became so common. Unfortunately, life became even harder once a fisherman retired from active duty. In the eighteenth century, most fishermen were forced out by the age of forty; some took up lobstering, clam digging, shore fishing or rigging, but making a living and supporting a large family was exceedingly difficult.[186] Vickers estimates that the average life span for fishermen in the period 1676 to 1775 was about forty-eight years. This was nine years shorter than the life span estimated for the years 1645 to 1675, when it was fifty-seven. He attributes this drop to the increased hardship involved with fishing in the eighteenth century (i.e., the more fish was in demand, the harder the fishermen worked).[187]

An example of a seventeenth-century fisherman's house on Hooper Street. *Photo by Lauren Fogle.*

The large families of many fishermen may have stemmed from the slightly earlier average marriage age in eighteenth-century Marblehead; many were already married by the age twenty-one. The sheer number of children born in the town was such that in the 1790 census, Marblehead was the only town in Essex County with a median male age under sixteen. As Vickers put it, "With a residential density that in 1790 exceeded every other town in Massachusetts save Boston, Marblehead was in the most meaningful sense overcrowded."[188] Again, the town tried to address the problem. In 1734, before the real boom in trade, the town petitioned the general court for an additional grant of land. The court obliged with a grant of six square miles of land near Falmouth, Maine. Any new settlers were to pay £1½ in cash, move to "New Marblehead," build a house there and clear seven acres of land for farming. Not surprisingly, since the new town was not near the sea, only a few families moved there and none was connected with the fisheries. Eventually the town was sold off to other interested parties and is now known as Windham, Maine.[189]

The fishery families may have decided to stay by the sea, but it was often at a huge cost. From January 1768 to January 1770, Marblehead lost twenty-three vessels, 163 seamen (not including the "merchant men," who were usually strangers and their deaths were not counted). There were 70 new widows in this two-year period and 155 children left fatherless.[190] Plus, despite the general harmony that many Marblehead merchants attempted to achieve with the fishing community, there were times when the wages and conditions were so unfavorable to the fishermen that they were forced to look elsewhere for work. Several times the fishermen of Marblehead posted notices in the *Essex Gazette*, claiming they "are dissatisfied with the Terms on which Owners of Vessels there have agreed to employ them the ensuing season." They then solicited any merchants, from Portsmouth, New Hampshire, to Plymouth, Massachusetts, who might need a schooner of fifty to seventy tons, to inquire at Marblehead for their services.[191]

Despite these incredible hardships, Marblehead's most prosperous period was the middle of the eighteenth century. As will be discussed in the following chapter, the American Revolution all but destroyed the shipping trade completely.

Daily Life: Put It in the Paper

There were several papers covering eastern Massachusetts during the eighteenth century, among them the *Salem Gazette*, the *Boston News-Letter*, *Massachusetts Gazette*, *Boston Gazette* and the *Essex Gazette*. The latter featured not only news of the day, but also a myriad of advertisements and public notices that told stories of their own. When someone died, for instance, the executor(s) of his or her estate would usually place a notice in the paper alerting the public to the death and inviting anyone with a debt owed to them from the deceased to contact the executor(s). This was separate from an obituary, which would run prior to the estate notice (Reverend John Barnard's obituary was front-page news in 1770). The owners of stolen or lost items were frequent contributors to the paper's notice section. Everything from stolen boats and canoes to runaway slaves or servants were advertised, usually with a reward to the person who returned them to the owner. Items for sale were also common: Benjamin Marston advertised the sale of the Misery Islands in 1769; farms were up for sale or lease; and houses and ships were auctioned off (frequently at the tavern of Richard Reed). Wet nurses, dentists, midwives and even a church pew at St. Michael's were advertised in the paper. When a Topsfield man's wife left him and refused to return, he put a notice in the paper forbidding anyone to give her shelter or money. During the turbulent early 1770s, the paper's decidedly anti-British tone was quite evident, though it remains a wonderful source for goings on in Essex County in the prelude to, and early days of the Revolution.

Masthead of the *Essex Gazette*.

FROM ROGUES TO REVOLUTIONARIES
Marblehead's War

What do we mean by The American Revolution? Do we mean the American War? The Revolution was effected before the war commenced. The Revolution was in the minds and hearts of the people; a change in their religious sentiments of their duties and obligations. This radical change in the principles, opinions, sentiments, and affections of the people, was the real American Revolution.
—John Adams, 1818

As John Adams rightly said, the Revolution was much more than a military conflict. It started, some would argue, decades before the first shots were fired in Lexington in April of 1775. It was a slow burn. New British taxes led to boycotts, riots, military occupation and a massacre, all years before war even broke out. In Marblehead, many townspeople were more concerned about the taxes being imposed by England than the continuation of prosperous trade between the town and the motherland.

The Stamp Act and the Nonimportation Agreements

In March of 1765, Parliament voted the first direct internal taxation on the American colonies. Known as the Stamp Act, it was a requirement that stamped paper costing a half penny to twenty shillings be affixed to newspapers, pamphlets, leases, legal documents, tavern licenses and the like. Needless to say, many colonial towns were in opposition, and Marblehead was one of them. Statements to this effect were common: "That it is the Desire of this Town that no Man in it will accept of the Office of distributing the Stamp Papers as he regards the Displeasure of the Town. And that they will deem this Person accepting of such Office an Enemy to his Country."[192]

At first, Marblehead calmly petitioned Parliament and the king to repeal the act. This had little effect. With the November 1 effective date fast approaching, twenty-two Marblehead couples married on the Sunday previous in order to avoid the tax on the marriage certificates. By the next month, Marblehead had joined other towns like Salem, Newburyport and Boston in boycotting the importation of British goods in protest of the Stamp Act.[193] A month later, on January 30, 1766, a ship arrived in Marblehead Harbor from Halifax and amongst its goods was a stamped newspaper, which the captain brought out and showed to the public. Hundreds of townspeople then gathered on Training Field Hill and burned the newspaper in a bonfire.[194] The tax was repealed in March of 1766, much to the delight of the colonists, who rang church bells, beat drums, built bonfires and staged "illuminations" using gunpowder.[195]

Despite the failure of the Stamp Act, Parliament was determined to pass new taxes on the colonies' imports. The Chancellor of the Exchequer, Charles Townshend, came up with a new set of taxes, known as the Townshend Acts, which imposed levies on glass, painters' colors, lead, tea and paper. In response, new nonimportation agreements were issued and signed by many towns, including Marblehead. In addition, a "circular letter" was drafted by the Massachusetts General Court in 1768 and sent to the legislatures of other colonies. The letter stated that only the colonies could tax themselves and encouraged a unified approach to resisting the new taxation. Despite pressure to retract this letter, the Massachusetts legislature voted ninety-two to seventeen to support the letter. The following day the legislature was dissolved by the British. Interestingly, Marblehead's representative, Jacob Fowle, was one of the seventeen who voted in favor of rescinding the letter. In July of that year, Marblehead voted to support the letter and claimed that Fowle's vote did not represent the feelings of the town as a whole.[196]

In 1769, following a series of meetings at A Bunch of Grapes tavern in Marblehead, a group of merchants and traders of the town agreed to halt the importation of all goods from Great Britain except coal, fishhooks, salt, lines, twine, hemp, duck, bar and sheet lead, shot, wool, cards and card wire, nails, powder, coarse kerseys (woolen cloth), half thicks (cloth), bays, rugs, blankets, Oznabrigs (unbleached fabric) and pepper. If any of these items were included in shipments already on their way to Marblehead, it was agreed that the items would be stored and not sold or used until the tax was repealed. This agreement was initially signed by between 50 and 60 merchants.[197] The official nonimportation agreements, which Marblehead signed as a town later in 1769, were seemingly a show of solidarity by the Marblehead merchants but were also extremely disruptive to the community

as a whole. When Marblehead voted to sign a further measure against the import of British tea, 712 heads of households signed it and 17 did not, but 7 of those later repented and signed. The 10 holdouts were called "unfriendly to the community" in the *Essex Gazette* and were prohibited from gaining licenses to sell liquor. When a chest of tea did arrive in the town from England, public pressure forced the purchaser to agree to reship it the next day. Before it was sent off to Boston, the tea chest was decorated with "some patriotic inscriptions," and was paraded around town by a group of townspeople. A story in the paper a few weeks later reported that the chest of tea never made it to Boston but that "the Tea may have taken the Road to Salem, Ipswich, or Newbury, which the true Sons of America would do well to make strict Enquiry after."[198]

Marblehead made its position very clear in May of 1770 when the results of a recent town meeting vote on the implementation of the nonimportation agreements were published in the *Essex Gazette*. Not only was any importer of British goods who decided to ignore the boycott called an "enemy to his country," but the same was extended to any individual who bought from and/or had any dealings with these importers. Names of the offenders would be published in the paper and reported to other towns in order to damage the reputations of these dissenters. A committee of inspection was organized and manned by some of the leading merchants and elite of the town, including Jeremiah Lee, Benjamin Marston, John Pedrick, Thomas Gerry, Azor Orne and Thomas Lewis. On behalf of this committee, Jeremiah Lee initially reported that there were currently no breaches of the agreement to be found in Marblehead.[199]

However, this policy of "outing" those who refused to abide by the agreement had evidently been going on for some time because the articles and advertisements in the paper had changed. In addition to touting his smorgasbord of delights (everything from spices, to horsewhips, to iron candlesticks, to Henry the Eighth playing cards), Thomas Lewis, himself a member of the committee of inspection, announced that all his goods had been imported before the agreement was signed, except for his array of cheeses, which he had been given permission to sell by the committee. It appears that dispensations were available and our diarist, Ashley Bowen, had one to buy English tea.[200]

A number of private disagreements were aired publicly in the papers. Marblehead merchants like Jacob Fowle & Son (the same Jacob Fowle who voted against the circular letter on behalf of Marblehead) wrote to the *Essex Gazette* and complained that they had been singled out by the nonimportation committee as breakers of the agreement, while they were in fact only selling items that had been imported on the brig *St. Paul* before the

agreement was signed. They took it a step further and accused the members of the committee of flouting the rules themselves and insinuated that many merchants in Marblehead were importing British goods despite the ban. An anonymous writer wrote a similar letter in defense of the merchant Thomas Robie, who had also been accused. John Sparhawk also wrote to the paper defending his shipment from the *St. Paul*, after his name was too published. All these merchants, except Thomas Robie, pledged support for the boycott in general and reviled the attempts by Great Britain to impose direct taxation on the colonies.[201]

Matters only grew tenser as time went on. Shopkeepers received threatening letters promising that their shops would be burned and they would be tarred and feathered, or even killed. One Boston merchant, James McMasters, ignored the nonimportation agreement and attempted to sell his goods in Marblehead. He ended up fleeing in fear for his life and found shelter only at "an obscure tavern" in Salem, since the main public house there denied him entry. Ships arriving from Rhode Island, where the nonimportation agreements were not altogether supported, were either denied entry to Marblehead Harbor or asked to depart.[202]

Solidarity

Certain events can be viewed as catapults; moments that push a dispute into a new, more radical and violent phase. The Boston Massacre on March 5, 1770, was one such event. British troops had poured into Boston to counteract any direct resistance as a result of the Townshend Acts. An altercation between a British solider and a mob of angry Bostonians wielding clubs resulted in the British opening fire, killing four colonists immediately and one who died days later. Horror and a lust for revenge filled the *Essex Gazette*'s pages in the following weeks. Marblehead and Salem pledged fifteen hundred men to march on Boston to avenge the murders, though no such march ever materialized. Marblehead's May 10 town meeting produced a hearty condemnation of the event: "[Our] highest Indignation and Resentment, that an ignorant, lawless, and bloody Soldiery, should attempt, of its own Authority, to fire upon and destroy so many of our Brethren."[203]

A year earlier, Marblehead had instructed its representatives to the colony's legislature to help better the relationship between them and England and refute the notion that they were "in open rebellion." Much had changed and the days of negotiations seemed numbered. However, after this period of dissent, there was a relaxing of the taxes that the colonists had protested

The ESSEX GAZETTE

Containing the freſheſt Advices, *both foreign and domeſtic.*

VOL. III.

NUMB. 136.

From TUESDAY, *February* 26, to TUESDAY, *March* 5, 1771.

SALEM : Printed by *Samuel Hall*, at his Printing-Office a few Doors above the Town-Houſe.

As a ſolemn and perpetual MEMORIAL

Of the Tyranny of the Britiſh Adminiſtration of Government in the Years 1768, 1769, and 1770 :

Of the fatal and deſtructive Conſequences of quartering Armies, in Time of Peace, in populous Cities :

Of the ridiculous Policy, and infamous Abſurdity, of ſupporting *Civil Government* by a *Military Force* :

Of the great Duty and Neceſſity of firmly oppoſing Deſpotiſm in its firſt Approaches :

Of the deteſtable Principles and arbitrary Conduct of thoſe *Miniſters* in Britain who adviſed, and of their *Tools* in America who deſired, the Introduction of a Standing Army into this Province in the Year 1768 :

Of the irrefragable Proof which thoſe Miniſters themſelves thereby produced, that the Civil Government, as by them adminiſtered, was weak, wicked, and tyrannical :

Of the vile Ingratitude and abominable Wickedneſs of every *American*, who abetted and encouraged, either in Thought, Word or Deed, the Eſtabliſhment of a Standing Army among his Countrymen :

Of the unaccountable Conduct of thoſe *Civil Governors*, the immediate Repreſentatives of his Majeſty, who, while the *Military* were triumphantly inſulting the whole LEGISLATIVE AUTHORITY OF THE STATE, and while the Blood of the maſſacred Inhabitants was flowing in the Streets, perſiſted in repeatedly diſclaiming all Authority of relieving the People, by any the leaſt Removal of the Troops :

And of the ſavage Cruelty of the IMMEDIATE PERPETRATORS ;

BE it forever Remembered,

That this Day, THE FIFTH OF MARCH, is the Anniverſary of

Preſton's Maſſacre--in King-Street--Boſton, N.England--1770.

In which Five of his Majeſty's Subjects were ſlain, and Six wounded,

By the Diſcharge of a Number of Muſkets from a Party of Soldiers under the Command of Capt. *Thomas Preſton.*

GOD Save the PEOPLE

SALEM. March 5, 1771.

Notice about the anniversary of the Boston Massacre in the *Essex Gazette*, February 26–March 5, 1771.

against, except for the tax on tea, which continued. Smuggled tea from other places became even more popular and was openly advertised. But tensions flared yet again when it was revealed, by Samuel Adams, that the governor of Massachusetts and the superior judges were being paid from the revenues of customs collections. Adams was key in creating the Committee of Correspondence, which synthesized the grievances of the colonies and then distributed them in written form to all the towns, encouraging them to discuss at town meetings. Marblehead received its letter in December of 1771 and it was read aloud by the town clerk at a town meeting. Adams also wrote separately to Marblehead's newly elected legislator, Elbridge Gerry, encouraging him to help ignite the town's response. A Committee of Grievances, including Gerry, then drafted several resolutions in staunch support of this letter, condemning the buildup of British troops in Massachusetts's towns and along the coast, and the paying of justices to

"bribe the present respectable gentlemen to become tools to their despotic administration."[204] They also spelled out their opposition to Parliament's insistence that colonial ships return from Spain and Portugal via England to pay the British import tax, instead of being allowed to pay the duties at the American ports. They specifically cited the wear on their vessels, the spoiling of perishable cargo and the extra manpower and food needed for these extended trips. Interestingly, they also accused Parliament of keeping the king unaware of the suffering of his colonial subjects.

Marblehead was the first town in Essex County to respond to the Boston letter. However, this patriotic response provoked a protest by twenty-nine well-known Marblehead merchants who claimed that only twenty Marblehead residents actually voted in favor of these resolutions, and therefore this was not representative of the town as a whole. They called the resolutions "rash and inconsiderate" in their letter, published in the *Essex Gazette*.[205] A lengthy rebuttal was printed in the next issue, stating that the resolutions had been discussed for over an hour and voted for by a group of eighty, not twenty. Furthermore, the responders claimed that the resolutions adopted were "almost the unanimous voice of the town."[206]

By 1773, Marblehead's town meetings were dominated by various resolutions in support of the colonies' right to import goods without taxation. Parliament attempted to deal with the taxation issue by testing the colonists' resolve. They adopted a new set of rules that allowed the East India Company to import half a million pounds of tea to the colonies without paying British duties or tariffs. This new legislation drastically reduced the costs of the East India Company, which had seen its profits dwindle due to mismanagement and the boycotting of British tea by the American colonists. This also made the price of tea tumble and undercut both the legitimate American tea merchants and the smugglers of Dutch tea that was being funneled into the colonies by men like John Hancock. With the price of tea at a record low, the British assumed that the colonists would rather accept a small tax than continue to deny themselves the tea. However, Boston publicly voiced its opposition and in early December of that year, Marblehead voted to adopt a resolution supporting Boston's resistance. A week later, on December 16, a group of Bostonians disguised as Mohawk Indians boarded three British ships laden with tea owned by the East India Company and dumped all the tea into Boston Harbor. This Boston Tea Party became famous as one of the major steppingstones to the American Revolution, though at the time outright military rebellion was still over a year away.

However, violence was becoming an increasingly useful tool for the colonists' cause. Most of the justices who were paid by the Crown were

pressured either to relinquish their salaries or resign their posts. One Salem justice, Nathaniel Ropes, resigned due to this pressure but was still harassed, even as he lay dying from smallpox. A mob amassed outside his home, broke windows and threatened to assault him physically.[207] The British responded to the heightened violence and sabotage with a quick succession of laws designed to subjugate and demoralize the colonists of Massachusetts. These became known as the Intolerable Acts, and they abolished all but annual town meetings (without permission of the governor), stripped the legislature of its right to choose its own council members and posted troops in Boston on a permanent basis. In March of 1774, the Boston Port Bill was enacted, which stipulated that no merchandise of any kind (other than food and fuel from coastal trade) could be loaded or offloaded at any Boston wharf after June 1, 1774. Not only was Boston closed for business, it was stripped of its capital status and the colony's government was moved to Salem, while the customs house went to Marblehead. The British viewed Salem as an excellent choice because of its long-standing, Loyalist minority who were still mainly in command of the town. Marblehead, of course, got the customs house due to its prominence in the shipping industry and its proximity to Salem, not its Loyalist tendencies.

Despite the abolition of town meetings, Marblehead convened one on May 23, 1774, to discuss "whether we shall hereafter be freemen or slaves." The townspeople chose a Committee of Correspondence and then adjourned the meeting until May 31. Forty-six meetings occurred like this, under one warrant and with adjournments, until April of 1775, ten months and ten days after the initial meeting.[208] In this way, they circumvented the new laws, since they called no more town meetings but simply continued the same one for nearly a year. One of the first issues discussed at this very long town meeting was the publication, in the *Essex Gazette*, of a letter in praise of former Governor Thomas Hutchinson. Hutchinson had lately been removed as governor by the British and replaced with Thomas Gage. This letter was signed by thirty-three citizens of Marblehead, much to the disgust of the members of the June town meeting, who felt it was a Loyalist ploy. They drafted a report that called the letter "false" and "malicious" and "designed to destroy the harmony of the town in its public affairs." They also claimed that "the numbers addressing Mr. Hutchinson, compared with the body of *Freeholders* in the Province, are but as a Drop in the Bucket."[209] They demanded that the signatories only be forgiven if they publicly recant and renounce the letter. Shortly, thirteen of the thirty-three had recanted and admitted their error. Captain Richard Stacey had signed the letter and then went on a rather long voyage. When he returned and realized the discord the letter had created in the town, he wrote another letter, published in the

Essex Gazette, stating his support for the ideas of liberty from Great Britain and renounced the address to Hutchinson completely.[210] One of the original signers of the letter was Jonathan Glover, who was one of the owners of the Essex Hospital. After its destruction, co-owners Gerry, Orne and John Glover resigned from the Committee of Correspondence/Grievances in protest of the way they had been treated by their fellow Marbleheaders.[211] This split in the Patriot leadership was short-lived, however.

With the devastating effects of the Boston Port Bill being felt by nearly everyone in the colony, Marblehead elected its latest representative to the general court in May 1774 and furnished him with a lengthy, detailed letter outlining the various steps and stances the town intended him to make on its behalf, including utter condemnation of the Port Bill and a rooting-out of Loyalists within the general court. The town also collected goods to help the poor of Boston who were suffering; eleven cartloads of fish and a cask of oil were donated by the Marbleheaders. Since the goods could not be shipped into Boston, they were carried overland through Cambridge. In addition, storage space in the Marblehead town house, powder house and twenty-eight other warehouses and wharves in the town was offered to Boston's merchants. In fact, relief for Bostonians came from all over the colonies, though the towns of Essex County gave the most.[212]

As word came of the convening of a Continental Congress in Philadelphia, Marblehead voted to send its representative and allocated the sum of £9, 8s for the representative's expenses. Jeremiah Lee, Azor Orne and Elbridge Gerry were all chosen, in turn, to be the representative, but all declined because their own affairs required their attention.[213] This points directly to the state of the economy at this time. Marblehead was suffering a downturn, as were all the other towns. The shipping trade was greatly diminished due to the nonimportation agreements, the Boston Port Bill and the danger in using any trade routes subject to the British. The extent to which the colonists went to help remove the French from north Atlantic fishing and trade in the decades previous was now painfully ironic. Eventually, Gerry accepted the position and went to Philadelphia.

After deciding that no East India tea should be sold, bought or consumed in Marblehead, the town formed a tea committee to keep track of any indiscretions. If people were found with the forbidden tea, their names were "posted at the Town House and at the several Churches that the town may know their enemies."[214] But it was not the constant issue of tea that nearly brought the locals into a battle with the British Regulars; it was their determination to continue having town meetings. On August 15, Marblehead's town meeting voted to start holding county meetings, with each town sending a representative. They sent a letter to this effect

Portrait of Elbridge Gerry. *Courtesy of the Marblehead Museum and Historical Society.*

ELBRIDGE GERRY.

to several Essex County towns and when Salem complied with this and called its meeting for August 24, to choose its representatives, Governor Gage took notice and forbade it. He activated the Fifty-ninth regiment, stationed on Salem Neck, and they marched to Salem, arriving after the town meeting had already adjourned. The regiment returned to the Neck and the governor had those in Salem who called the town meeting arrested and charged with sedition. When he refused to release them from jail, a mob of three thousand armed men stood ready in the adjacent towns to rescue the men. Marblehead had sent a message that they were "ready to come at a minute's warning."[215]

In the following month, there was an actual altercation between a group of young Marbleheaders and a member of the regiment of British troops stationed on Marblehead Neck. Captain Merritt of Marblehead came to the youths' aid and was seriously wounded by the soldier's bayonet. The soldier was then disciplined by the British and given five hundred lashes.[216] This eased tensions somewhat, but it had become clear to Governor Gage that the subjugation of the colonists would never be achieved without more British troops in the colony. In fact, the county-wide meeting that the Marbleheaders

The Azor Orne house on Orne Street. *Photo by Lauren Fogle.*

had suggested went ahead in early September in Ipswich. Marblehead chose Jeremiah Lee, Elbridge Gerry, William Doliber and Joshua and Azor Orne to represent the town and the county committee agreed to, in effect, ignore the new laws against town meetings and continue to hold them. All elected officials, who were now to be replaced with British appointees, were told to stay in their positions and not comply with the act (officially named the Massachusetts Government Act). Of the thirty-six new appointees, twenty-one either resigned or refused to accept the position in the first place, including the Loyalist Robert Hooper of Marblehead.

The First Continental Congress drafted the Association, a document that called for the end to indirect taxes on many commodities and imposed a ban on all exported/imported goods to and from Britain and all imported East India Company tea from anywhere in the world. Imports from the British West Indies were also outlawed. Once in receipt of the Association, Marblehead chose a committee to enforce it. The Association also encouraged frugality and the indulgence in frivolity soon became unacceptable. A Mr. Hilliard was summoned to a Marblehead town meeting to explain his continued use of a billiard table.[217] However, Great Britain fired back and passed the New England Restraining Act, which prohibited any colonial trade with non-British nations. Marblehead's lucrative trade with Spain, Portugal and the Spanish and French West Indies would be decimated under this new rule. With their very livelihoods at stake, many who felt caught between the Loyalist and revolutionary causes made their choice and began preparations for war.

The Loyalists

The terms "Tory" and "Whig," though ubiquitous in the language of the American Revolution, were actually already in use in England prior to the war. The Tories were staunch Anglicans, supporters of the divine right of kings and believers in an agrarian economy. The Whigs supported more religious tolerance (though most were themselves Anglicans), the supremacy of a parliamentary system of government and an industrial, market economy. The Tories and Whigs of colonial America were along the same lines, though it cannot be said that all Tories were Anglicans, or vice versa. For the most part, American Tories supported British rule and the Whigs did not. It is perhaps then better to refer to them as Loyalists and revolutionaries. Amongst the major merchants of Marblehead, loyalty to the king was more common than amongst the general public. The sentiment tended to run in families and many Loyalists kept their opinions to themselves and were more observers

than participants in the revolutionary politics of the colony. Ashley Bowen was himself a Loyalist and feared he might starve to death during the war since none of his fellow townspeople would sell food or drink to him. Even water was withheld from the Loyalists under orders from what Bowen referred to as "headquarters." Eventually, he was forced to give up the rigging trade and sell hay from his father's barn to survive. In all, Bowen made very few political statements in his journal, but instead remained somewhat aloof and ambivalent about the events surrounding him. However, just after the Stamp Act was repealed, he did mention the reaction of a fellow Loyalist in his diary: "An excellent member of society, civil and ecclesiastical, from pure and unadulterated patriotism, displayed his feelings by a golden candlestick for the place of the king, and a silver candlestick for each of his ministers, beautifully illuminating his illuminated house."[218]

When Governor Gage first came to Salem, the colony's new capital, in June of 1774, he was met by and dined with "principle Gentlemen" from Salem and Marblehead. A ball was held the next day at the home of Colonel William Browne in Salem, to celebrate the king's birthday. Gage spent most of the summer at Robert Hooper's country estate in Danvers.[219] The Anglican churches of both Salem and Marblehead issued letters to Gage to assure him that they planned to "cultivate a Spirit of Loyalty, to the King, and Obedience to the Rulers that are set over us."[220] Salem was known for its prominent Loyalists, who had written a letter in support of the former Governor Hutchinson very similar to the one initially signed by thirty-three Marbleheaders. While the Marblehead Loyalists were heavily pressured and ostracized for their beliefs, those in Salem enjoyed less hostility, as their numbers were larger and they were quite influential. Nevertheless, there was a "Tory Headquarters" in Marblehead, where presumably the town Loyalists met. This headquarters was actually the house/warehouse of Thomas Robie, a merchant and owner of the aforementioned "hardware" store. Robie never agreed with the nonimportation agreements and was an avowed Loyalist. However, serious tensions between him and his fellow Marbleheaders only erupted when he was accused of selling barrels of powder at too high a price. Eventually, Robie and his wife were forced to leave Marblehead for Nova Scotia and many townspeople saw them off at the dock with taunts and jibes. Mrs. Robie left her former neighbors with her wish that the streets of the town would fill with rebel blood.[221]

Benjamin Marston was another prosperous Loyalist merchant who found Marblehead a suddenly inhospitable place. In 1775, his house was raided by a mob of townspeople who stole money, account books and the like. Marston escaped to Boston to stay with friends, and later moved to Halifax with his family.[222] Others, like Jacob Fowle and John Prince, publicly recanted

The "Tory Headquarters" and Thomas Robie house/warehouse on Washington Street. *Photo by Lauren Fogle.*

and apologized for having signed the letter in support of former Governor Hutchinson. The supporters of this letter had become symbols of the Loyalist ethos and fell under extreme pressure to change sides, which all but ten of them did.[223]

By October of 1774, anyone accepting an appointed position from the British was entered in town records as "rebels against the state." The irony of the rebels labeling the Loyalists as rebels may have been lost in the fray and many avowed Loyalists either switched sides (at least publicly) or simply remained silent. Still, there were others who eventually chose exile (Hooper, Marston and Robie, among others) and some who chose to stay and withstand the public pressure. Marblehead voted to have the names of Hooper, Marston, Robie, John Pedrick, Nathan Bowen and John Prentice printed in the *Essex Gazette* if they refused to recant their support for former Governor Hutchinson and the Crown in general.[224] For all his wealth, influence and strong connections with Marblehead, King Hooper died bankrupt and exiled from his town in 1790. One of his sons, Joseph, was also exiled from the town, his property was confiscated and three attempts were made to burn down his house, known as "Tory Hall" to the revolutionaries.[225]

A Town's Fight

The organization had begun. The provincial congress that had formed despite the threats of Governor Gage created two committees—the Committee on Safety and the Committee of Supplies—to spearhead the military buildup in October of 1774. Marbleheaders Azor Orne, Jeremiah Lee and Elbridge Gerry were members of these committees and helped organize the smuggling of weapons out of Boston and Charlestown and the theft of cannons and powder from Portsmouth and Newport. In response to the mobilization, the British stationed HMS *Lively* off Marblehead to search incoming vessels and generally keep an eye on things. In February of 1775, Samuel Trevett of Marblehead led a nighttime raid on the *Lively* and removed a good deal of weaponry and powder, all of which went to outfit the Marblehead regiment. This regiment, though it had existed for some time, was remade due to the looming conflict with Britain. The former officers, Gage appointees, had either resigned under public pressure or been dismissed by a vote of the town. New officers were then chosen and the sum of £800 was allocated to outfit and train the new regiment. Privates received two shillings daily; sergeants, clerks, drummers and fifers got three shillings each; second lieutenants received four shillings; first lieutenants got four shillings six-pence; and captains received six shillings. The men needed to serve four hours a day for three days a week to receive this compensation.[226] News of Marblehead's enthusiastic mobilization had reached as far as New York; the Loyalist *New York Gazette* reported that "the mad-men of Marblehead are preparing for an early campaign against his Majesty's troops."[227]

It was not long before Marblehead's regiment would be mustered and called on to defend the town from British regulars. On February 26, 1775, a regiment of British soldiers, commanded by Colonel Leslie, landed at Homan's Beach (between Fort Sewall and the Landing) and marched through the town. The British arrived on a Sunday morning, around church time, but failed to understand the culture of the town they were in. Not only were quite a number of townspeople not at church, but they were taking keen notice of the regiment's arrival. Presuming that the colonel's objective was actually artillery hidden in Salem, Major John Pedrick of the Marblehead regiment rode ahead to Salem and sounded the alarm at the North Church. Soon members of both the Marblehead and Salem regiments gathered at the North Bridge, which was raised, and waited for Leslie and his men to arrive. When the British demanded the bridge be lowered, they were refused and the few men of Leslie's regiment who attempted to cross to the other side in boats were repelled with threats

of immediate sinking. One Marbleheader, Robert Wormstead, actually disarmed six British soldiers with his cane as a weapon, though no actual battle was fought. Leslie managed to negotiate his way across the bridge at last, with the help of Reverend Barnard (who had come to preach peace) but Leslie was not able to achieve his objective and therefore retreated to Marblehead and returned to his ship.[228]

The slide to all-out war was short from here. The battle of Lexington and Concord was fought on April 19, 1775, and although the news that the British had suffered many losses at the hands of the Minutemen was met with enthusiasm in Marblehead, another event marked a loss for the town. The day before the battle, the Committee for Safety and Supplies— of which Jeremiah Lee, Azor Orne and Elbridge Gerry were members— met at Wetherby's Black Horse Tavern on the road from Lexington to Cambridge. That night, as some members of the committee slept at the tavern, groups of British regulars passed by outside and, feeling threatened, the men escaped into a nearby cornfield to await the departure of the troops. Their rooms were searched by the British, so the escape was well worth it, although Lee soon fell ill as a result of several hours in the freezing field. He caught a fever and died from it just days later.[229] Marblehead had lost one of its most successful merchants and ardent Patriots just when the town needed him the most.

Despite the early military successes, this was an uneasy time in Marblehead. The *Lively* had been sent to Boston and was replaced by the *Merlin*. British press gangs were becoming even more "persuasive" on the streets of the town. Some Marbleheaders even attempted to rescue those who had been pressed and were being held in British ships in the harbor. The recently established Continental army was also recruiting and its officers marched around the town with fife and drums. With the harbor relatively unprotected from a British attack, many wealthier and Loyalist families moved away from the town to the safer environs of country houses in Danvers, Boxford, Newbury and the like. Those who remained were predominately supporters of the revolutionary cause and often watched the regiment perform maneuvers on training days. The town was also brimming with Bostonians, many of whom were escaping the difficulties there and for whom Marblehead seemed a safer place.

The constant threat of attack kept everyone in a state of readiness. Drums sounded when British vessels approached either Salem Harbor or the Ferry area of Marblehead. Since the British were seizing any ships laden with useful goods, some Marblehead ships stationed themselves offshore to warn other incoming vessels to divert to Newburyport and offload there. Despite the blockade of Boston, Marbleheaders succeeded in landing salt

at Boston ports in smaller boats, although they were warned against this by the commander of the *Merlin*. Realizing the extreme danger posed by the *Merlin*, Marblehead voted to reconstruct the fort at Gale's Head (known now as Fort Sewall). Men worked long hours for most of the fall of 1775 and General Lee, second in command at the Continental army headquarters in Cambridge, came personally to check on the building progress.[230] In December, just days after the completion of the fort, three British warships sailed toward Marblehead Harbor and the general alarm was raised. General Washington was informed and ordered the Marblehead regiment to march to Marblehead from Cambridge. All women and children were advised to leave the town and the men manned the cannons at the fort. After a two-hour standoff, the ships sailed out to sea, leaving Marblehead to wonder what would have occurred had they been fired upon since, despite their new, shiny cannons, there was absolutely no powder at the fort.[231] Several other batteries were built in the coming year: one near Hooper's Wharf, one at Bartol's Head (Crocker Park), one at Hewett's Head (the sea side of "Seaside" park) and one on Twisden's Hill.

The town's poor were suffering as usual, but now there was less money for their maintenance because most of it had gone, and would continue to go, to the Marblehead regiment. During the fall of 1775, the poor were advised to "dig stumps and turf out of the swamps for fuel." By December, the Society of Friends of Philadelphia had arrived in town to assist the poor and went from house to house with the selectmen, deciding who needed the most urgent assistance. Bowen referred to them as "the seven wise men from the South."[232] A visitor to Marblehead in 1776 wrote, "Their [the poor's] situation is miserable, the street and roads are fill'd with the poor little boys and girls who are forc'd to beg of all they see."[233]

Ashley Bowen recorded not only the various ships that entered and exited Marblehead Harbor during the early days of the war, but also the church services, or lack thereof, at St. Michael's and the two meetinghouses. Often the ministers were absent from town, living in the countryside, and therefore the churches were dark. Bowen also recorded his disgust at the various military exercises that occurred on Sundays during the war. To his horror, things only got worse. After the Declaration of Independence in 1776, St. Michael's was ravaged by townspeople hostile to the Church of England. The Royal Coat of Arms was torn off the wall and the bell was rung until it cracked. The church was officially closed down in 1777 and only reopened for lay readings in 1780. It was reestablished permanently in 1786.[234]

Birth of the Navy

The first commissioned naval vessel "fitted out in the service of the United States," was the schooner *Hannah* in late 1775. The *Hannah* was owned by John Glover and was used for a short time and then put aside in favor of several other Marblehead vessels that were refitted to be ships of war: the *Franklin, Hancock, Lee, Warren* and *Lynch*. Two Marbleheaders were picked by General Washington to lead missions to intercept British ships bound for Quebec and relieve them of their ammunition stores. Nicholas Broughton took the *Lynch* and John Selman the *Franklin* and both ventured forth to Quebec. Although the vessels they sought had escaped, they captured ten others and also stormed a fort on the island of St. John, taking both the governor of the island and a judge as prisoners. Their efforts were not well received by General Washington, who had planned on keeping friendly with the northern provinces and felt Broughton and Selman had greatly overstepped their bounds.[235] Captain John Manly of Marblehead commanded the *Lee*, the first ship authorized to "protect the sea-coast," and succeeded in besting a number of British vessels and confiscating their supplies. These ships, organized by John Glover and commanded by Manley and others, made up Washington's initial fleet and were the origins of the American navy.[236]

Perhaps the most famous Marblehead wartime sea captain was Captain James Mugford, who began his military career after being pressed into British naval service, only to be released due to the persuasive pleas of his wife. Once free, Mugford immediately offered the Continental army information he had gathered while he was a prisoner. His captors had spoken of a "powder ship" on its way from England to reinforce the British army and Mugford proposed that he capture it. In May of 1776 he did just that, boarding the *Hope* as it approached Boston Harbor. This was the most valuable prize of the war thus far. Just a week later, Mugford was again sailing his schooner, *Franklin*, through the channel called Pudding Point Gut (which leads out from Boston Harbor to the open sea) when his ship ran aground. He was quickly surrounded by British ships and though the *Franklin* sunk two of them almost immediately, many British sailors attempted to board the schooner and Mugford was mortally wounded by a shot to the chest. His crew grew even more intent after the death of their commander and succeeded in protecting their ship. While the British lost seventy men in the engagement, the *Franklin* lost only their leader, Mugford. The *Franklin* was able to sail away from Pudding Point Gut with the tide and sped up to Marblehead, where the townspeople were waiting in huge numbers, pressed up against the shoreline. Mugford's elaborate funeral was held the following week and his body was

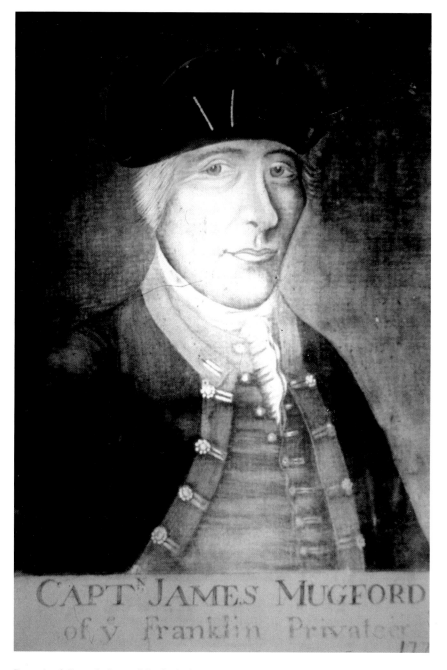

Portrait of Captain James Mugford. *Courtesy of the Marblehead Museum and Historical Society.*

escorted from the New Meeting House (Second Church) to Old Burial Hill by the Marblehead regiment.[237]

Glover's Regiment

John Glover, a successful merchant and influential man in town, was made the official commander of the Marblehead regiment in June of 1775 by the provincial congress. Glover was stationed at Marblehead until June 21, when he and the regiment reported for duty in Cambridge. Although they were not heavily involved in the battle of Bunker Hill, his fellow Marbleheader, Captain Trevett (the raider of the *Lively*) and his artillery company did fight in the battle and managed to capture two British cannons, the only ones to be captured by the Continentals.[238] Glover's regiment spent January to July of 1776 at Beverly before joining General Washington in New York. Despite a brawl (or snowball fight) that the regiment had with a group of Continentals from Virginia while camped at Cambridge, Glover and his men commanded the respect of many of the officers of the new army. A young captain from Pennsylvania, Alexander Graydon, wrote of his disappointment with many of the soldiers from New England: "[They did] not entirely come up to the ideas we had formed of the heroes of Lexington and Bunker Hill." Grayson found little fault with Glover's regiment, however, remarking only that it was "disagreeable" and "degrading" that there should be black men in the regiment.[239] Marblehead's regiment did contain several blacks, including "Black Joe," who ran a tavern in Marblehead after the war and whose house still stands on Gingerbread Hill. What Grayson did admire was no doubt the regiment's discipline and fearless attitude. Years at sea had taught the men these skills and even their uniforms, short blue jackets, white caps and sailors' pants, showed their attachment to the sea. The regiment's first major success was its important role in the retreat from Brooklyn in August of 1776, when nine thousand troops and loads of equipment were evacuated across the East River at night. David McCullough captured the scene in his book *1776*:

> *Glover's men proved as crucial as the change in the wind. In a feat of extraordinary seamanship, at the helm and manning oars hour after hour, they negotiated the river's swift, contrary currents in boats so loaded with troops and supplies, horses and cannon, that the water was often but inches below the gunnels—and all in pitch dark, with no running lights. Few men ever had so much riding on their skill, or were under such pressure, or performed so superbly.*[240]

Glover and his men also ferried the sick and wounded across the Hudson River to the Jersey shore and in the next month, when the bulk of Washington's forces was retreating toward White Plains, Glover's regiment was involved in fighting the British as they advanced near Pelham Bay. Engaging the enemy from behind stone walls, Glover and his men inflicted many casualties and allowed Washington and the army to evade capture. This event, though less well known, was one of the most important land-based events that Glover took part in during the war.[241]

On Christmas night, Glover's men again ferried the army across a treacherous river, this time the Delaware, which led to the successful attack on the Hessian encampment at Trenton. Numerous depictions of this crossing have been painted, some with key historical errors, but the importance and extreme difficulty of the task cannot be underestimated. Colonel Henry Knox, who was in charge of the overall operation, later wrote of how the ice on the river made the task of crossing "almost incredible" and how the Marbleheaders had "almost infinite difficulty" getting the eighteen field cannon and fifty horses across the fast, partially frozen river.[242] "The fishermen of Marblehead," he later said, "alike at home upon land or water, alike ardent, patriotic, and unflinching, whenever they unfurled the flag of the country."[243]

John Glover, whose regiment fought with the Continental army many times throughout the war, was promoted to general and Colonel William Lee of Marblehead, one of the most distinguished officers of the regiment, was eventually made adjutant-general of the American army.

The Toll

In 1780, three years before the end of the war, there were 831 men left in Marblehead, half of them unemployed. Of those who had not yet returned from the war but were not confirmed dead, 121 were missing and 166 were prisoners of the British. There remained 1,069 women in the town, nearly 40 percent of whom were widows. The children numbered 2,343 and over a third of those were fatherless. In 1775, 12,313 tons of shipping were "owned, employed, manned" in Marblehead. After the war, this number had fallen to 1,509 tons.[244] The booming prewar trading economy had been decimated and the residents of the town were forced to return to the fishing trade for survival. Nathan Bowen reported that two thirds of Marblehead families were without wood or meat in 1780.[245] Inflation made many necessities just too expensive and houses and fish shacks were pulled down for fuel. In efforts to aid the town, the colonial legislature forgave two-thirds of the taxes on beef, spices and currency, and also reduced the number of men the town

had to provide to the army.[246] Despite this help, the town was forced to sell common land to pay for the maintenance of the new recruits the town still had to provide to the army; "Bubier's Plain" (roughly today's Goldthwait neighborhood) was sold to John Sparhawk for just over £217. Marblehead also owed the town treasurer, Jonathan Glover, over £1,000, since he had been boosting the town's finances for years from his own wallet. In order to pay him back, a wharf once refurbished by Robert Hooper was sold for £800.[247] In all, Marblehead sent over 40 percent of its population (some 1,780 men) to fight in the Revolution.[248] For certain, only the Bostonians can claim to have shouted, bled and sacrificed more for the sake of revolution than those who did so in Marblehead.

EPILOGUE

Postwar Marblehead never recovered its former economic glory and descriptions of the town in the early years of an independent America were less than becoming. Simeon Baldwin, a teacher at Yale University, took a tour of several New England coastal towns and had this to say about the Marbleheaders in 1784:

> The people are savage in their nature & education—are very poor in general—amazingly prolific & exceed all places in the habit of begging, one can hardly ride thro' the Town without being accosted in that way by one half of the old women & children in it.[249]

In truth, the town did have a large proportion of widows and children (459 widows and 865 orphaned or fatherless children around 1790). However, Marblehead still retained its reputation as an important port and revolutionary stronghold. In 1784, the Marquis de Lafayette, Washington's friend and supporter of the Revolution, visited Marblehead. He addressed the following to the people of the town:

> While I have the satisfaction once more to enter a town which so early fought and so freely bled in the great conflict, admiration with the tender concerns of a sympathizing heart. But, amidst our regrets of brave men who had the honor to fall in their country's cause, I rejoice in the virtuous spirit and animating industry remarkable in the remaining sons of Marblehead.[250]

A few years later, an even higher profile visitor arrived. President George Washington made a trip to New England and briefly visited Marblehead in 1789. He noted in his diary some of the same things other diarists had

written: "Houses are old; the streets dirty; and the common people not very clean." But it was his decision to visit the town at all that is interesting. He wrote that Marblehead was "four miles out of the way, but I wanted to see it."[251] No doubt Washington had not forgotten about General John Glover and his men, or the town's fervent and outspoken support for the war. Glover, now a selectman, took part in drafting a letter to the president on behalf of the town, in which he mentioned, not without embarrassment, "the too visible decay and poverty of this town":

> *The establishment by the United States of a secure and efficient Government, gives us the pleasing expectation of the gradual revival of our Fishery and Commerce, objects of the industry, and the principle means of the subsistence of the Inhabitants of this place for above a century previous to the late Revolution. In the commencement of the contest with Great Britain, this Town was early in their exertions in the common cause, and were not discouraged when they foresaw that reverse of their situation which the war has necessarily produced. The return of the Peace did not restore to us the former advantages of the Fishery, which hath remained under peculiar discouragements; and we have yet patiently to expect that attention of the General Government which may remedy these evils, and which the subject may deserve from its extensive importance to the commerce of the United States.[252]*

The president replied to the town in a letter a few days later, offering hopeful words but no promises. Little had changed by 1791, when a Salem minister and diarist, William Bentley, visited Marblehead and found the local townspeople immoral, superstitious and "as profane, intemperate, & ungoverned as any people on the Continent." He was, however, very impressed with both the Marblehead regiment and the various members of the merchant elite (namely members of the Orne and the Lee families) with whom he dined. He also made mention of the rise of Beverly in the fishing business and that, at least in this year, Marblehead had only brought in ten thousand quintals more of fish, despite having over twice the number of vessels as its northern neighbor.[253] The town's inability to match its prewar numbers in terms of fish and trade goods made it harder and harder for the relatively large population to rise out of poverty. The loss of men at sea and war had chipped away at the town's workforce and the result was not only women and children begging in the streets, but also several deaths from starvation and exposure. Bentley also mentioned that the town house was boarded up on the lower level and "shattered" on the upper floors. This state of dilapidation speaks volumes about the condition of the town in the first decade after the Revolution.

Although the sweeping changes of the nineteenth and twentieth centuries are not within the purview of this history, it is important to note that the rise of non-fishing related industries in the town was a direct result of the slow but steady collapse of the trade in fish and foreign goods brought on by the ravages of the Revolution. Well into the nineteenth century, the town was described as "the quaintest and most dilapidated of seaports," and many would say that the townspeople had changed little from the early days of the seventeenth-century settlement; still ungovernable, still rogues.[254] In 1846, a devastating storm killed sixty-three of the town's fishermen and ruined the Marblehead fishery for good. Vickers wrote, "The town that in colonial times was the greatest fishing port in the New World had turned its back on the sea altogether."

However, others might focus on the legacy the Marbleheaders of the eighteenth century left us: a firm place in the pantheon of revolutionary forerunners and a famous harbor that would once again be frequented by those who love the sea, though more for pleasure than survival. Regardless, it is certainly illuminating to remember that Marblehead, now a relatively small place within a large country, was once a big place, both in population and importance, and very much in the vanguard of shaping the nation we have today.

NOTES

Town Beginnings

1. Roads, *History and Traditions of Marblehead*, 2–4. The original deed hangs in Abbot Hall, Marblehead.

2. Gray, *Founding of Marblehead*, 6.

3. Roads, *History and Traditions of Marblehead*, 10. It was first called "Marble Harbor" by Reverend Francis Higginson, who had arrived in Salem in 1629 and then written a letter to his friends back in England describing the area (including Salem) in this way. See Gray, *Founding of Marblehead*, 5.

4. Searle, *Marblehead Great Neck*, 1. The town was also called "Foy," after a town of the same name (though spelled "Fowey") in southern Cornwall, by the Englishman Samuel Maverick in 1660. See Dow, *Two Centuries of Travel*, 28.

5. Roads, *History and Traditions of Marblehead*, 16. Marbleheaders joined their Salem counterparts in fighting the Pequot tribe in 1637 and the Narragansett in 1675. See Phillips, *Salem in the Seventeenth Century*, 134, 233.

6. Dow, *Two Centuries of Travel*, 16–17.

7. Perley, "Marblehead in the Year 1700," 2–3. "The Plains" was predominantly a farm of approximately five hundred acres owned by John Humphrey, who also owned parts of what is now eastern Swampscott. Over the years, farming plots were sold to various people, especially in what is now the Goldthwait neighborhood, the areas west of Pleasant Street (Route 114) and south of Ocean Avenue.

8. Roads, *History and Traditions of Marblehead*, 18.

9. Ibid., 24.

10. Ibid., 14 n. 1. This area became mostly pastureland.

11. This area was also known as "Darbie Fort"—possibly a reference to a Castle in Dorset. See Perley, "Marblehead in the Year 1700" 8, vol. 67 (1911), 341.

12. Bowden, "MTR," *EIHC* 69, 229.

13. Searle, *Marblehead Great Neck*, 2–4.

14. Roads, *History and Traditions of Marblehead*, 24; Perley, "Marblehead in the Year 1700," 5.

15. Roads, *History and Traditions of Marblehead*, 9.

16. Ibid., 11.

17. Gray, *Founding of Marblehead*, 12.

18. Vickers, *Farmers and Fishermen*, 102.

19. Ibid., 108 n. 53. Several of Marblehead's most prosperous early merchants, like William Nick, died hundreds of pounds in debt. See Vickers, *Farmers and Fishermen*, 111.

20. Phillips, *Salem in the Seventeenth Century*, 110–11.

21. Bowden, "MTR," 247–50. See also Konig, *Law and Society*, 41.

22. Gray, *Founding of Marblehead*, 13. John Humphrey was one of the founders of the Massachusetts Bay Company and was related (by marriage) to English royalty. See Phillips, *Salem in the Seventeenth Century*, 112.

23. Vickers, *Farmers and Fishermen*, 95.

24. The court at Salem offered to spare him the fine and allow him to continue his building if he agreed to cut his long hair. He refused. See Roads, *History and Traditions of Marblehead*, 12.

25. Bowden, "MTR," 207–09. Humphrey did retain about 450 acres of his land until his death. See Perley, "Marblehead in the Year 1700," 2–3.

26. Heyrman, *Commerce and Culture*, 213.

27. Typical town expenses in 1672: Payment to town minister, Mr. Cheever, £80; bridge at Forest River, £4, 5 shillings.; Widow Slater, 11 shillings.; fort and guns, £3, 12 shillings, 3 pence; work done on meetinghouse; wine for the raising of a lean-to at the meeting house; watchmen on the Neck; ringing of the bell; six pair of shoes; one pair of stockings; wooden dishes (unspecified amounts). See Bowden, "MTR," 272.

28. Bowden, "MTR," 228.

29. Perley, "Marblehead in the Year 1700," 5.

30. Roads, *History and Traditions of Marblehead*, 24.

31. Ibid., 37–39. Cotton also noted that Marblehead was far from a town of scholars; there was one, Ames Cheever, the son of the minister, who attended Harvard.

32. Ibid., 39.

33. Bowden, "MTR," 227. The ferry cost two pence.

34. Ibid., 216. The number of livestock per capita was relatively low compared to other towns in the colony. Around 1657, forty-four families were recorded as owning cows, with no one family owning more than two of them.

35. Smith, *Journals of Ashley Bowen*, 211.

36. Perley, "Marblehead in the Year 1700" 3, 223–4. This hill also housed the town's pound, or home for stray animals, in 1698. See Perley, "Marblehead in the Year 1700," 221. The pound had previously been at the corner of Mugford and Mechanic Streets and later was moved to the corner of Elm and Pearl Streets. See Perley, "Marblehead in the Year 1700" 5, 70. Belknap puts the date of the corn mill at 1670, ten years earlier. See Belknap, *Trades and Tradesmen*, 68.

37. Representatives of Salem and Marblehead discussed building another mill on the Forest River in 1663, but it appears that it was never finished. See Belknap, *Trades and Tradesmen*, 35, 67; Perley, "Marblehead in the Year 1700" vol. 9, 68, 82.

38. Perley, "Marblehead in the Year 1700," 5.

39. Bowden, "MTR," 315.

40. Three men owned deeds and had built houses on the Neck between 1663 and 1700: John Pedrick, John Searl and Andrew Tucker. See Perley, "Marblehead in the Year 1700," 15.

41. "MTR" 1648–1710 (original, Abbot Hall).

42. Hugh Peters, who owned land in Marblehead near Devereux Beach, was an exception. He lived in the Massachusetts Bay Colony for fourteen years before his Puritan zealotry forced him back to England to fight with Cromwell against King Charles I. He was eventually executed in London in 1660, after Charles II was restored to the throne. See Roads, *History and Traditions of Marblehead*, 21.

43. Bowden, "MTR," 213.

44. Ibid.

45. Heyrman, *Commerce and Culture*, 213.

46. Such a vote refused entry to Philip Welch of Topsfield, who was ruled too poor to be admitted to Marblehead. See Bowden, "MTR," 289.

47. Heyrman, *Commerce and Culture*, 215–17.

48. Perhaps the best-known event involving the women of early Marblehead was the murder of several Native Americans who were being held prisoner (or slaves) in the town after King Philip's War, the conflict between the colonists and the native tribes of southern Massachusetts Bay Colony in 1656–57. Increase Mather, the prominent Boston minister (among others), recorded that the women came out of the meetinghouse and killed the natives, who were outside, with their bare hands. In fairness, the women were most likely reacting to the loss of a ship to the war and the death of a number of Marblehead men. Nevertheless, the act was brutal and quite shocking. See Axtell, "Vengeful Women of Marblehead," 647–52.

49. Heyrman, *Commerce and Culture*, 215.

50. Konig, *Law and Society*, 71.

51. Roads, *History and Traditions of Marblehead*, 45. A "translator" arrived in the town in 1664, possibly to help translate between the French-speaking islanders and the English speakers. See Belknap, *Trades and Tradesmen*, 68.

52. According to Vickers's statistics, Marblehead had a crime rate about four times higher than other towns with a similar population—accounting for one quarter of all violent crimes in seventeenth-century Essex County. See Vickers, *Farmers and Fishermen*, 128.

53. Heyrman, *Commerce and Culture*, 217, 218 n. 14. There were also many less violent offenses mentioned in the records in 1636, like "being a liar," "using tobacco in the open," being baptized twice, stealing a goat and building a well on public land. However, the records also mention "biting the constable's hands" and the murder of five children, the youngest just one year old, by their own father.

54. Roads, *History and Traditions of Marblehead*, 13–14.

55. See Belknap, *Trades and Tradesmen*, 81; and Bowden, "Commerce of Marblehead," 121.

56. Roads, *History and Traditions of Marblehead*, 8.

57. Ibid., 26.

58. Heyrman, *Commerce and Culture*, 218.

59. Vickers, *Farmers and Fishermen*, 140.

60. Heyrman, *Commerce and Culture*, 220. The aforementioned tavern owner, Christopher Lattimore, was also a selectman.

61. Pierce, *Records of the First Church of Salem*, 121, 125.

62. Roads, *History and Traditions of Marblehead*, 9.

63. Ibid., 14; Heyrman, *Commerce and Culture*, 222.

64. Cheever's membership was 50 people at the inception. In his thirty-two-year tenure, Cheever saw 41 men and 160 women join the church; 345 people recognize the covenant; and 1,557 people baptized. See *Under the Golden Cod*, 23; and Pierce, *Records of the First Church of Salem*, 159.

65. Wilmot Redd was accused of souring the milk, which led to the death of infants, and causing the extreme constipation of a previous employer (among other things). Though not directly implicated by her fellow townspeople, no one from Marblehead came to her defense or went to see her during her months in a Salem jail. See Roads, *History and Traditions of Marblehead*, 31; and Peterson, *Marblehead*, 29.

66. Dow, *Two Centuries of Travel*, 47.

67. The townspeople had so little money that they often used fish to barter with each other, and with those from other towns. See Roads, *History and Traditions of Marblehead*, 23.

68. Heyrman, *Commerce and Culture*, 227.

69. Roads, *History and Traditions of Marblehead*, 23.

70. Heyrman, *Commerce and Culture*, 232–33.

A TOWN'S FAITH

71. Edward Brattle epitomized these newcomer elites. Part of a powerful merchant family, he watched over family interests in Marblehead, but his allegiance, contacts and sympathies were believed by many to lie with Boston and Bostonians. See Heyrman, *Commerce and Culture*, 274–75.

72. Ibid., 278 n. 5.

73. The term "Anglican," meaning "of the Church of England," has often been used interchangeably with the term "Episcopalian." However, the American Episcopalian Church was not organized until after the Revolution in 1783, when it was forced to officially break with the Church of England. In the colonial town, St. Michael's was often referred to as a "church," while the First and Second Churches were called "meetinghouses."

74. Roads, *History and Traditions of Marblehead*, 41. The original timber structure is the oldest standing Episcopalian/Anglican church in Massachusetts.

75. Barrow, "Church Politics in Marblehead," 122.

76. The population of Marblehead was 4,954 in 1765, and therefore perhaps closer to 4,800 around the time of the establishment of St. Michael's. See *Vital Records of Marblehead*. Some of the church's earliest attendees were actually members of Salem's First Church, most fishermen and their families, who sailed to Marblehead to attend St. Michael's "until it appeared more like a day of frolicking." See Phillips, *Salem in the Eighteenth Century*, 70.

77. Heyrman, *Commerce and Culture*, 280–81 n. 7. Interestingly, Barrow saw little common ground between the followers of the Second Church and the Anglicans; he saw Barnard's faction as the more tolerant toward the Church of England, hence the agreement, and the Second Church as distrustful of outsiders and

more intolerant. See Barrow, "Church Politics in Marblehead," 126–27. Dorothy Miles, author of *Church of Our Fathers*, saw Barnard's Anglican sympathies as a major cause of the schism at the First Church. See Miles, *Church of Our Fathers*, 24.

78. Barrow, "Church Politics in Marblehead," 122. The actual agreement was rediscovered in the mid-twentieth century and is in the collection at the Peabody Essex Museum/Philips Library.

79. The Second Church sat on the site that is now occupied by the Unitarian Universalist Church of Marblehead, on Mugford Street.

80. Heyrman reported that Barnard himself was "appalled" by the agreement with the Anglicans and refused to take the helm at the First Church unless Holyoke was settled in his own church and the agreement with St. Michael's was voided. However, Barnard had warmed to Anglicanism on a journey to England before he came to Marblehead and was even on a list of donors to St. Michaels; he gave three pounds. See Barrow, "Church Politics in Marblehead," 125.

81. Pierce, *Records of the First Church of Salem*, 245.

82. Eliot, "Topographical and Historical Account of Marblehead."

83. Further analysis of this will follow. In *Under the Golden Cod*, however, the forming of the Second Church was described as following "a dispute." See *Under the Golden Cod*, 23.

84. Barnard, *Autobiography of John Barnard*, 232.

85. William H. Bowden argued that it was not just Swett who began the resurgence of Marblehead shipping, but also the Lees, the Minots and Joshua Orne. See Bowden, "Commerce of Marblehead," 122.

86. Barnard, *Autobiography of John Barnard*, 239–41.

87. Ibid., 234.

88. Ibid., 243. Masson left for Virginia in 1727.

89. Barnard recalled the church's sexton saying that St. Michael's "was the healthiest church in the country, for they had never buried a minister yet, though they had had four, who all run away." See Barnard, *Autobiography of John Barnard*, 234.

90. Checkley did eventually receive orders, via the Bishop of Exeter, and was settled in Narraganset. See Barnard, *Autobiography of John Barnard*, 229.

91. Ibid. A "non-Juror" was a person who refused to swear an oath of allegiance to the monarch. Many Anglican priests were non-jurors.

92. Barnard, *Autobiography of John Barnard*, 232.

93. Knight, *Ashton's Memorial*.

94. Bowen, "Interleaved Almanacs of Nathan Bowen," 164.

95. Ibid., 165. Rhodes was a middle-class shoreman who began preaching and holding evening meetings that were attended by large groups of women. See Heyrman, *Commerce and Culture*, 375.

96. Bowen, "Interleaved Almanacs of Nathan Bowen."

97. Heyrman, *Commerce and Culture*, 367.

98. Ibid., 370.

99. Ibid., 373. Heyrman pointed out that the strong presence of lower-class women in the revival reflects the extreme hardships that they, as a group, suffered from more than any other group. War, storms and the fishing trade in general

often left them without husbands, with children to feed and almost no means to do it. Therefore, their participation in the revival was a means of release and inspiration. See Heyrman, *Commerce and Culture*, 380–83.

100. Barnard, *Autobiography of John Barnard*, 230. George Whitefield was one of the Great Awakening's chief characters, an English preacher who traveled around New England. He gave a sermon in Marblehead, probably in front of the town house, but wrote in his journal that it was "not with much visible effect." See Dow, *Two Centuries of Travel*, 71

101. Barnard, *Autobiography of John Barnard*, 230.

102. Ibid., 399.

The Great Distemper

103. "MTR", 1764–88, 261; Roads, *History and Traditions of Marblehead*, 49-50.

104. Blinderman, "John Adams," 274–75.

105. Heyrman, *Commerce and Culture*, 305.

106. Dr. Zabdiel Boylston, a pioneer of inoculation, had been successful and published the details of his work.

107. Holyoke was inoculated during the first outbreak in 1721 and stayed for a while at the home of Cotton Mather, since Marblehead had forbidden the inoculated to reside in the town.

108. This account of the riot comes from Heyrman, *Commerce and Culture*, 305–12. Depositions taken from many of the men involved are preserved and are the main sources for the details of this event.

109. Ibid., 325.

110. Bowen was a seafarer in his younger days and a ship rigger in Marblehead thereafter. His journals contain much information on his daily life and also drawings of many kinds. His father was the aforementioned Nathan Bowen, lawyer.

111. Smith, *Journals of Ashley Bowen*, 352–53. The selectmen reserved the right to requisition any house or building for use as an almshouse or "pesthouse" during an outbreak. Twenty-three people died at the Ferry house within two months, and at least eight others after that. See Roads, *History and Traditions of Marblehead*, 91. The Ferry area was in more ways than one a place for undesirables; when the French and Indian War landed around one thousand French Acadian refugees in Massachusetts, Marblehead's portion (thirty-seven) was housed at the Ferry and supported by the town. See Phillips, *Salem in the Eighteenth Century*, 199; Bowen, "French Neutrals in Marblehead," 168.

112. Smith, *Journals of Ashley Bowen*, 353. This was likely not referring to the current Neck, but Peach's Point and the area called "Black Joe's Cove" (Gracie Oliver's Beach). See Roads, *History and Traditions of Marblehead*, 91.

113. Dow, *Two Centuries of Travel*, 79. This information came via a report that was compiled in 1773 by Deputy Postmaster General Hugh Finlay.

114. Smith, *Journals of Ashley Bowen*, 353 n. 1. The "Market-House" is the town house and the market was on the lower level.

115. Ibid., 358, 384. It wasn't until February 2, 1774, almost five months later, that Bowen again recorded, "No smallpox today."

116. Ibid., 466. There were also smallpox outbreaks in 1752, which were described as devastating but not as bad as those of 1730, and in 1764, when a smallpox hospital was built just northwest of the almshouse. See Roads, *History and Traditions of Marblehead*, 62, 71.

117. After receiving the permission of the Salem authorities, who opened their own inoculation hospital in Salem in November of 1773, the proprietors bought the island from William Wait for £133 6 shillings 8 pence in September of 1773. See Roads, *History and Traditions of Marblehead*, 92. See also Hercher, "Cat Island."

118. *TEG*, September 28–October 5, 1773.

119. Ibid., October 26–November 2, 1773. An advertisement in an earlier edition touted the work of Ibrahim Mustafa, official inoculator to His Sublime Highness, the Turkish Sultan. Mustafa used a new needle that caused fewer complications; however, he addressed himself only to "the Nobility and Gentry of this city [Salem]." See *TEG*, February 11–18, 1772.

120. *TEG*, November 16–23, 1773.

121. Ibid., January 11–18, 1774.

122. Ibid.

123. Smith, *Journals of Ashley Bowen*, 381–82. This event might easily have been predicted, since an entry in the previous week's *Essex Gazette* read, "WANTED—A quantity of damaged feathers—also an old one-horse cart." See *TEG*, January 11–18, 1774; Phillips, *Salem in the Eighteenth Century*, 339.

124. Smith, *Journals of Ashley Bowen*, 383.

125. Roads, *History and Traditions of Marblehead*, 93–94.

126. *TEG*, January 25–February 1, 1774.

127. Smith, *Journals of Ashley Bowen*, 385 n. 8.

128. *TEG*, February 22–March 1, 1774; March 1–8, 1774.

129. Ibid., March 29–April 5, 1774.

130. Smith, *Journals of Ashley Bowen*, 301.

131. Ibid., 489.

132. Ibid., 516–18.

BOOMTOWN

133. Heyrman, 232. These wars were also known as the "French and Indian wars"—not to be confused with the French and Indian War, 1754–63, which was known in Europe as the Seven Years' War (even though it lasted for nine).

134. Ibid., 245.

135. Ibid., 248–49. There were fifteen violent crimes and eleven involving theft in Marblehead during those years, compared with four of each in Salem. The only murder recorded in Marblehead in the first half of the eighteenth century involved two fishermen; John Royall killed Christopher Codner with a cane.

136. "MTR", 1723, 233.

137. Ibid. Other estimates put the number of schooners in the mid-eighteenth century at about eighty; see Roads, *History and Traditions of Marblehead*, 60. The Marbleheaders petitioned Lieutenant Governor Dummer to repair their harbor in 1727; see Smith, *Journals of Ashley Bowen*, 29.

138. Roads, *History and Traditions of Marblehead*, 60.

139. Smith, *Journals of Ashley Bowen*, 138. Hamilton's assessment of the town's population is probably too high.

140. Heyrman, *Commerce and Culture*, 331.

141. Bowden, "Commerce of Marblehead," 134.

142. Ibid., 123.

143. Ibid., 126.

144. Ibid., 129. The repetition of certain items was probably due to this list being a combination of several people's shipments. Bbls. is an abbreviation for "barrels."

145. Outgoing ships with their destinations, along with incoming ships, were recorded not only in the customs records, but also printed in papers like the *Essex Gazette*.

146. Billias, *Elbridge Gerry*, 4.

147. Heyrman, *Commerce and Culture*, 332.

148. Ibid., 333. The most serious challenge during this period was Spain's decision to halt all commerce between itself and the colonies. Soldiers on the Louisburg campaign sailed in ships manned by Marbleheaders.

149. They sailed from Marblehead on April 12, 1759, with Ashley Bowen among them as a midshipman. See Roads, *History and Traditions of Marblehead*, 66.

150. Ibid., 334.

151. Ibid., 77.

152. Ibid., 342.

153. Bowden, "Commerce of Marblehead," 126. His father left an estate assessed at £6,542, including three warehouses, eleven schooners, fine furniture and plates, English goods totaling £1,500 and 414 gallons of rum.

154. Ibid., 125.

155. Tapley, "Richard Skinner," 7, 18.

156. Ibid., 24–25.

157. Heyrman, *Commerce and Culture*, 347–48. One such collaboration involved Swett and Hooper, who asked their Lisbon contact for help obtaining the release of two Marblehead seamen from a Spanish prison. These seamen were part of the crew of a vessel owned by their colleague, Joshua Orne. For more on fishing superstitions, see Peterson, *Marblehead*.

158. Bowden, "Commerce of Marblehead," 123; Roads, *History and Traditions of Marblehead*, 63.

159. The old schoolhouse, founded by Bowen in 1724, was closed because squatters had taken up residence and were building fires, despite the fact that the building lacked a fireplace. See MTR, 1720–64, 358, 361; Roads, *History and Traditions of Marblehead*, 5, 61–62. Newtown Bridge straddled the "brick ponds" that were in the area between Pleasant and Washington Streets, along School Street. See Smith, *Journals of Ashley Bowen*, 6.

160. Phillips, *Salem in the Eighteenth Century*, 342.

161. Ashley Bowen, being a ship's rigger for the later part of his life, often worked at the ropewalk. See Smith, *Journals of Ashley Bowen*, 169. There may have actually been two ropewalks, one on either side of Barnard Street. See Perley, "Marblehead in the Year 1700," no. 2, 178–84.

162. Heyrman, *Commerce and Culture*, 359.

163. Ibid., 360–61.

164. Tapley, "Richard Skinner," 6.

165. The former meetinghouse was also a place of worship, originally located at Old Burial Hill. The 1727 town house was primarily a place for town meeting and a market. See Roads, *History and Traditions of Marblehead*, 48.

166. Several Marblehead vessels were attacked by the French, including the schooner *Swallow*, which was owned by Robert Hooper. Ashley Bowen was among the *Swallow*'s seamen and was taken prisoner. Ashley's brother, Nathan, was himself taken prisoner when the ship he was master of, *The Prince of Orange*, was captured by the French. He was imprisoned in Bayonne Castle in southwest France. See Smith, *Journals of Ashley Bowen*, 138; Roads, *History and Traditions of Marblehead*, 65.

167. Roads, *History and Traditions of Marblehead*, 64.

168. Perley, "Marblehead in the Year 1700," 70.

169. Roads, *History and Traditions of Marblehead*, 78–79.

170. *TEG*, January 21–28, 1772.

171. For an in-depth account of road building and the names of roads by time period, see Perley, "Marblehead in the Year 1700."

172. Dow, *Two Centuries of Travel*, 88.

173. *TEG*, July 25, 1768; August 29–September 5, 1769; September 5–12, 1769; January 30–February 6, 1770.

174. Ibid., March 26–April 2, 1771.

175. Ibid., June 26–July 3, 1770.

176. Bowden, "Commerce in Marblehead," 123.

177. *TEG*, November 5–12, 1771.

178. Dow, *Two Centuries of Travel*, 76.

179. Vickers, *Farmers and Fishermen*, 168. Fishermen were also unlikely to own woodworking tools, livestock or firearms.

180. Roads, *History and Traditions of Marblehead*, 62.

181. Barnard, *Fanua Coelestis*.

182. Heyrman, *Commerce and Culture*, 239.

183. Ibid. See also Feer, "Imprisonment for Debt," 252–69.

184. This was located at the corner of the current Pearl and Elm Streets. See Roads, *History and Traditions of Marblehead*, 69. Individuals also sometimes left money to the poor in their wills. Dr. Joseph Lemmon left nearly £14 to the First Church to be used for a baptismal basin, unless the church had already acquired such a basin, in which case the poor widows of the congregation were to have the sum. See Old North Church Records, "Gifts to Our Church."

185. Heyrman, *Commerce and Culture*, 241.

186. Vickers, *Farmers and Fishermen*, 184–85. Nathaniel Dennen was a retired fisherman who worked often in the rigging loft of Ashley Bowen.

187. Heyrman, *Commerce and Culture*, 255 n. 39.

188. Vickers, *Farmers and Fishermen*, 187–88.

189. Ibid., 190. Residents of Windham were summoned to a Marblehead town meeting to choose officers and discuss unpaid taxes in 1772. See *TEG*, July 7–14, 1772.

190. *TEG*, December 26–January 2, 1770.
191. Ibid., December 25–31, 1771; December 31–January 7, 1772.

FROM ROGUES TO REVOLUTIONARIES
192. Tagney, *County in Revolution*, 20, 26.
193. Ibid., 27–28.
194. Smith, *Journals of Ashley Bowen*, 141.
195. Tagney, *County in Revolution*, 29. Interestingly, there were those who felt Marblehead did not take a strong enough stand against the Stamp Act. A sarcastic letter was printed in the *Boston Evening Post* in December of 1767 accusing both Salem and Marblehead of having "the greatest inclination to comply with it [the Stamp Act] of any towns in the province." This letter was prompted by Salem's initial decision not to support a vote by Boston to abstain from all goods taxed in the Townshend Acts and the somewhat ignorant belief that Marblehead was inextricably linked politically to Salem.
196. Tagney, *County in Revolution*, 38–39; *TEG*, August 2, 1768.
197. *TEG*, October 24–31, 1769.
198. Ibid., October 17–24, 1769; October 31–November 7, 1769; May 8–15, 1770; Roads, *History and Traditions of Marblehead*, 83, 86. The ten dissenters were reported as William Goodwin Sr., William Peach, William Hammon Sr., Thomas Dolliber's widow, Samuel Gooden's wife, Amos Hubbard's wife, Bejamin Valpee, Abraham Mullet's widow, Samuel Rogers and Robert Jamison.
199. Ibid. See also "MTR", 1764–88, 164.
200. *TEG*, February 6–13, 1770; Smith, *Journals of Ashley Bowen*, 248.
201. *TEG*, December 19–26, 1769.
202. Ibid., June 12–19; June 26–July 8, 1770.
203. Ibid., May 8–15, 1770. Similar condemnations continued on the anniversary of the event for several years, with extensive expressions in the local papers.
204. Ibid., December 8–15, 1772.
205. Ibid.
206. Ibid., December 22–28, 1772.
207. Tagney, *County in Revolution*, 79.
208. Roads, *History and Traditions of Marblehead*, 98.
209. *TEG*, May 31–June 7, 1774.
210. Tapley, "Captain Richard Stacey," 84.
211. Tagney, *County in Revolution*, 100.
212. Roads, *History and Traditions of Marblehead*, 102; Tagney, *County in Revolution*, 89.
213. Ibid.
214. Roads, *History and Traditions of Marblehead*, 104.
215. Tagney, *County in Revolution*, 9; Phillips, *Salem in the Eighteenth Century*, 331.
216. Tagney, *County in Revolution*, 105.
217. Ibid., 119; "MTR", December 21, 1774.
218. Smith, *Journals of Ashley Bowen*, 141, 453–54.
219. Tagney, *County in Revolution*, 84. Hooper had previously entertained Governor Hutchinson at his house in Marblehead. See *TEG*, April 26, 1774.
220. *TEG*, May 17–24, 1774.

221. Roads, *History and Traditions of Marblehead*, 126–27.
222. Ibid.
223. *TEG*, June 7–11, 1774.
224. Tagney, *County in Revolution*, 107.
225. Ibid., 278.
226. Roads, *History and Traditions of Marblehead*, 110–11.
227. *TEG*, February 14–21, 1775.
228. Roads, *History and Traditions of Marblehead*, 111–12. Roads took most of this information from private manuscripts of the Pedrick family.
229. Ibid., 113–14.
230. Tagney, *County in Revolution*, 238.
231. Ibid., 242. Many other Essex County towns were in a similar situation with regard to lack of powder.
232. Smith, *Journals of Ashley Bowen*, 427–28, 441–42, 445, 456, 469.
233. Ibid., 471.
234. Ibid., 508.
235. Roads, *History and Traditions of Marblehead*, 118–19.
236. Tutt, "Washington's Fleet," 298–99. There has been an ongoing debate about whether Beverly can claim to be the birthplace of the American navy due to the fact that the *Hannah* originally sailed from there. Most historians, like Tutt, are happy to concede that point, but remain firm that the navy was conceived by Marbleheaders; built, owned and captained by Marbleheaders; and was therefore truly born in that town more than any other. There was another ship in this early fleet, the *Harrison*, which was out of Plymouth.
237. Roads, *History and Traditions of Marblehead*, 121–23.
238. One man from Glover's regiment and two from Trevett's regiment were killed in action at Bunker Hill. See Tagney, *County in Revolution*, 198.
239. McCullough, *1776*, 120.
240. Ibid., 188.
241. Baller, "Kingship and Culture," 293.
242. Ibid., 274.
243. Roads, *History and Traditions of Marblehead*, 156.
244. Ibid., 134.
245. Roads, *Marblehead Manual*, 12; Smith, *Journals of Ashley Bowen*, 551.
246. Roads, *History and Traditions of Marblehead*, 134.
247. Ibid., 135.
248. Baller, "Kingship and Culture," 291.

EPILOGUE
249. Dow, *Two Centuries of Travel*, 96.
250. Roads, *History and Traditions of Marblehead*, 201.
251. Ibid., 167.
252. Ibid., 209.
253. Dow, *Two Centuries of Travel*, 125–27.
254. Drake, *New England Legends and Folklore*, 208.

BIBLIOGRAPHY

Axtell, James. "The Vengeful Women of Marblehead: Robert Roule's Disposition of 1677." *William and Mary Quarterly* 31 (1974): 647–52.

Baller, Bill. "Kingship and Culture in the Mobilization of Colonial Massachusetts." *Historian* 57 (1995): 291–300.

Barnard, Reverend John. *Autobiography of John Barnard*. Massachusetts Historical Society Collections, 3ʳᵈ series, vol. 5. Boston: John H. Eastburn, 1836.

———. *Fanua Coelestis*. Dedication. Boston: Rogers and Fowle, 1750.

Barrow, Thomas. "Church Politics in Marblehead, 1715." *EIHC* 98 (1962): 121–27.

Belknap, Henry Wyckoff. *Trades and Tradesmen of Essex County Massachusetts: Chiefly of the Seventeenth Century.* Salem: Essex Institute, 1929.

Billias, George Athan. *Elbridge Gerry: Founding Father and Republican Statesman.* New York: McGraw Hill: 1976.

———. *General John Glover and his Marblehead Mariners.* New York: Henry Holt & Co., 1960.

Blinderman, A. "John Adams: fears, depressions and ailments." *New York State Journal of Medicine* 77 (1977): 268–76.

Bowden, William Hammond. "The Commerce of Marblehead." *EIHC* 68 (1932): 117–46.

———. "Marblehead Town Records." *EIHC* 69 (1933): 207–329.

Bowen, Nathan. "French Neutrals in Marblehead, 1756." *EIHC* 70 (1934): 168.

———. "Interleaved Almanacs of Nathan Bowen." *EIHC* 91 (1955): 164–66.

Dow, George Francis. *Two Centuries of Travel in Essex County, Massachusetts, 1605–1799*. Topsfield, MA: Topsfield Historical Society, 1921.

Drake, Samuel Adams. *Book of New England Legends and Folklore*. Boston: Roberts Bros., 1884.

Eliot, Reverend John. "A Topographical and Historical Account of Marblehead." *Massachusetts Historical Society Collections* 8 (1802).

Essex Gazette, 1768–76. Peabody Essex Museum Collection, Phillips Library.

Fagan, Brian M. *The Little Ice Age: How Climate Made History 1300–1850*. New York: Basic Books, 2000.

Feer, Robert A. "Imprisonment for Debt in Massachusetts Before 1800." *Mississippi Valley Historical Review* 48 (1961): 252–69.

Gaustad, Edwin. "Society and the Great Awakening." *William and Mary Quarterly* 11 (1954): 566–57.

Gray, Thomas E. *The Founding of Marblehead*. Baltimore: Gateway Press, 1984.

Hercher, Gail Pike. "Cat Island: A History of Kings, Captains and Children… Just Off the Coast of Marblehead." *Marblehead Magazine*, http://www.legendinc.com/Pages/MarbleheadNet/MM/Articles/CatIslandHistory.html.

Heyrman, Christine Leigh. *Commerce and Culture: The Maritime Communities of Colonial Massachusetts 1690–1750*. New York: W.W. Norton & Co., 1984.

Knight, Russell W., ed. *Ashton's Memorial: A History of the Strange Adventures and Signal Deliverances of Philip Ashton, Jr., of Marblehead*. Salem: Peabody Museum of Salem, 1976.

Konig, David Thomas. *Law and Society in Puritan Massachusetts: Essex County 1629–1692.* Chapel Hill: University of North Carolina Press, 1979.

Lord, Priscilla Sawyer, and Virginia Clegg Gamage. *The Spirit of '76 Lives Here: Marblehead.* Radnor, PA: Chilton Book Company, 1972.

"Marblehead Town Records, 1720–1764." Marblehead, Town Clerk's Office, Abbot Hall.

"Marblehead Town Records, 1764–1788." Marblehead, Town Clerk's Office, Abbot Hall.

McCullough, David. *1776.* New York: Simon & Schuster, 2005.

Miles, Dorothy. *Church of Our Fathers: The Story of Old St. Michael's Church.* Marblehead, 1976.

Old North Church Records, Marblehead, MA.

Perley, Sidney. "Marblehead in the Year 1700." *EIHC* 66, 67, nos. 1–8 (1910–11).

Peterson, Pam Matthias. *Marblehead: Myths, Legends and Lore.* Charleston, SC: The History Press, 2007.

Phillips, James Duncan. *Salem in the Eighteenth Century.* Boston: Houghton Mifflin & Co., 1937.

————. *Salem in the Seventeenth Century.* Boston: Houghton Mifflin & Co., 1933.

Pierce, Richard D., ed. *The Records of the First Church of Salem, Massachusetts, 1629–1736.* Salem: Essex Institute, 1974.

Roads, Samuel, Jr. *History and Traditions of Marblehead.* Boston: Houghton Mifflin & Co., 1881.

————, ed. *The Marblehead Manuel: Extracts from the Journal of Nathan Bowen and Edward Bowen, 1757–1808.* Boston: Statesian Publishing, 1883.

Searle, Richard Whiting. *Marblehead Great Neck.* Salem: Newcomb & Gauss, 1937.

Sheppard, John H. *The Life of Samuel Tucker: Commodore in the American Revolution.* Boston: Alfred Mudge and Son, 1868.

Smith, Philip Chadwick Foster, ed. *The Journals of Ashley Bowen.* 2 vols. Peabody, MA: Peabody Museum of Salem, 1973.

Tagney, R.N. *A County in Revolution.* Manchester, MA: The Cricket Press, 1976.

Tapley, Harriet Silvester. "Captain Richard Stacey of Marblehead." *EIHC* 51 (1920): 81–110.

―――. "Richard Skinner, An Early Eighteenth Century Merchant of Marblehead." *EIHC* 68 (1932): 5–29.

Tutt, Richard. "Washington's Fleet and Marblehead's Part in Its Creation." *EIHC* 81 (1945): 291–304.

Under the Golden Cod: A shared history of the Old North Church and the town of Marblehead, Massachusetts 1635–1985. New Canaan, NH: Phoenix Publishing, 1984.

Vickers, Daniel. *Farmers and Fishermen: Two Centuries of Work in Essex County, Massachusetts, 1630–1850.* Chapel Hill: University of North Carolina Press, 1994.

Vital Records of Marblehead Massachusetts to the End of the Year 1849. 2 vols. Salem: Essex Institute, 1903.

INDEX

I

inoculation 51, 52, 54, 56, 58, 60

J

Jersey 25, 63

L

Lee, Jeremiah 69, 97, 98
Loyalists 94, 95

M

Manly, John 100
Marblehead Neck 23
Marblehead regiment 40, 97, 99, 102
Marston, Benjamin 68, 95
merchants 68, 69, 70, 86
Mugford, James 100

N

Native Americans 17, 51
Naumkeag 17
Newfoundland 25
newspapers 81
nonimportation agreements 84, 85

O

Old Burial Hill 27

P

Peach's Point 17, 19, 20
poor 27, 67, 77, 99

R

roads 21, 23, 73
Robie, Thomas 74, 95

S

Salem 18, 20, 24, 27, 59, 71, 89, 91, 95, 97
Salem witch trials 27, 35
schools 21, 68, 70
Second Church 38, 47, 48, 54
shops 74, 86
smallpox 51, 52, 54, 55, 56, 58, 60
St. Michael's (Anglican church) 37, 38, 41, 42, 48, 54, 99
Stamp Act 83
strangers 24, 63
Swett, Joseph 41, 68

T

taverns 26
tea tax 88, 90
town house 43, 72, 106
town meetings 89, 90
Trevett, Samuel 97, 102

W

Washington, George 105, 106
weather 75
widows 27, 67, 80, 103, 105
windmill 23, 72
women 24

ABOUT THE AUTHOR

Lauren Fogle began her life as a Marbleheader at the age of three months. Since then, she and her family have loved the town like no other. She spent nearly fifteen years away, attended college and worked in Washington, D.C., and then moved to England, where she received her MA and PhD in history from the University of London. After a brief stint in Ireland, Lauren and her husband returned to America and now live in Marblehead with their young daughter.

Visit us at
www.historypress.net